Amphoto Guide to

SLR
Photography

Dolores Brown

AMPHOTO
American Photographic Book Publishing
An Imprint of Watson-Guptill Publications
New York, New York

Note: In the appendix of this book you will find a table for converting U.S. Customary measurements to the metric system. You will also find a table for ASA and DIN equivalents.

All photos in this book were taken by the author unless credit is given otherwise.

Library of Congress Cataloging in Publication Data
Brown, Dolores, 1930-
 The Amphoto guide to SLR photography.

 (Amphoto guide series)
 Includes index.
 1. Single-lens reflex cameras. 2. Photography—
Handbooks, manuals, etc. I. Title.
TR261.B76 770'.28'22 80-29174

ISBN 0-8174-2516-0
ISBN 0-8174-2178-5 (pbk.)

Manufactured in the United States of America

OTHER BOOKS IN THE AMPHOTO GUIDE SERIES

Available now

Dedication

I dedicate this book to all those from whom I have learned, and to those who will learn from it.

Acknowledgements

I would be remiss if thanks weren't given to some very special people: to Herb Taylor, for his patience and understanding and the many advanced deadlines; Lou Jacobs, Jr., whose sharp and succinct comments as editor were most helpful; Greg Lewis, without whose assistance the book would not have been completed; to all those students and friends who provided many of the photo illustrations; to Maureen Sechrengost, for her hours in the darkroom and her artistic talents; and, most of all, to Jim, for his encouragement, assistance, moral support, and forbearance throughout the whole project.

Contents

Introduction

In my photography classes at U.C.L.A. Extension, an evaluation sheet given to each student includes these questions: "Are you satisfied with your photographs taken during your travel and otherwise? If not, why not?"

Some answers over the past few years have been: "There is something of 'sameness' about them"; "Uninspiring"; "Lacking vitality"; "Mine look too much like snapshots"; "There's no artistic approach"; "They don't capture the feeling or culture of the country"; "Uninteresting"; "They're boring"; "Not worth showing to friends"; "Not very imaginative"; "Too much like postcards".

I suspect that such reactions are not confined to photography classes, but that many readers may feel their pictures are disappointing, and that you have acquired this book in the hope of improving your slides and prints.

We all attempt to create excitement with our pictures, for ourselves and for others. We want remembrances of a place, a person, an event. We want to stimulate, provoke, inspire, fascinate with our photographs. For most of us, a simple record on film isn't enough. So we take classes, join camera clubs, and buy books on photography. We want something more: more pleasing, more dramatic, more exciting. We'd like to be "photographers" rather than "snapshooters".

This book is written for those who are serious about photography, serious enough to want pictures that are not ordinary, that have pictorial distinction. At the same time, it is intended to help you to become more comfortable with your equipment, so that you can concentrate on artis-

7

tic and creative efforts. So why, you may ask, concentrate on single-lens-reflex equipment?

Well, why do the majority of hobbyists and professionals use SLRs in preference to other cameras?

It's simple. A single-lens reflex camera is lightweight and compact, has slow and fast shutter speeds, offers versatility by using lenses that can be changed in a matter of seconds, enables the user to view, compose, and focus right through the lens, is quick to load, and usually has built-in exposure meters or completely automatic exposure setting. These features make this type of camera the easiest, most convenient, most versatile tool for achieving more excitement in your photographs. There is little you can't learn to shoot with your SLR.

1

Cameras

The 35mm single-lens reflex (SLR) has fast become the most popular camera of both professional and amateur photographers. The SLRs of today are versatile and sophisticated, yet every year a wider variety of accessories and features are available. A joy to use, these cameras offer photographers the opportunity to make exciting, imaginative, technically correct pictures after only a short get-acquainted session.

If you have just purchased a SLR and are not yet familiar with it, or if you are interested in acquiring your first camera, this chapter will help you learn about the many dials, rings, levers, and other controls to be found on almost all modern SLRs. If you're already fully familiar with your equipment you may wish to skip this chapter and move ahead to the next one.

THE CAMERA BODY

The camera body has three basic functions: to provide a light-tight box to hold the film, to support the lens that focuses the light rays onto the film, and to house the viewfinder and exposure controls that give you, the photographer, the choice over what the camera does. Let us discuss these vital controls one by one.

Outside the Body

Shutter-speed dial. On a few SLRs, the shutter-speed control is a ring around the lens mount. More common are shutter-speed dials on top of the camera body as illustrated here. The numbers on the dial are shutter

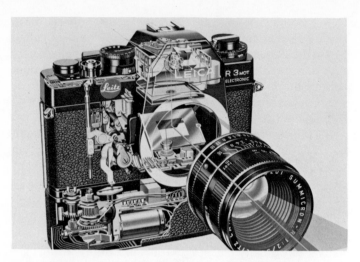

The cutaway view of the Leica R3 shows the viewing system. Light enters the lens, then is reflected by the mirror into the prism and through the viewfinder to your eye. You do not need to learn all the internal parts of a camera—leave those to a competent camera repairshop if malfunctions occur. You should become acquainted with your camera's controls, though, and these are shown and discussed throughout this chapter.

speeds; they represent fractions of a second. For example, "1000" stands for 1/1000 of a second, "60" stands for 1/60 second, and "1" means one full second. Some cameras offer speeds longer than one second, such as two, four, and eight seconds; these numbers are usually engraved on the dial in a different color from the fractional speeds.

The "B" stands for *bulb,* a holdover from the old days when a rubber bulb was squeezed to open the shutter. When set on "B" the shutter will stay open as long as you hold the release button down.

You may see one speed engraved in red on the shutter-speed dial; this is usually 1/60 or 1/125. Some manufacturers may add a letter "X" following that number, or perhaps a lightning-bolt symbol. These are simply various ways of indicating the fastest shutter speed you can use when working with electronic flash. Although you can use slower speeds with flash, this is usually done under special circumstances, which will be discussed later; for average situations, use the speed indicated by the manufacturer.

Some cameras do not have shutter-speed dials. These cameras automatically set the shutter speed called for by the camera's metering system. Shutter-speed is an important creative control, however, and if you are considering buying such an automatic camera, be sure there is a way to override the automation. Ask the salesman in your camera store.

Film-speed dial. This is where you adjust the camera's built-in light meter to match the film's sensitivity. On both the examples shown the film-speed dial is a part of the shutter-speed dial. Through a small window (usually marked *ASA* or *DIN*) you see the speed number of the film you are using. Once you have set this, the camera's meter is properly informed.

Shutter release. This is the button you normally press to take a picture. The button is usually threaded so that you can screw in a cable release.

Film-advance lever. Located on the right hand side of the camera, usually on top and near the shutter release, is the lever that advances the film and cocks the shutter for the next shot.

Exposure counter, also called a frame counter. This shows a series of numbers through a small window, on top of or on the back of a camera, indicating the number of exposures made. (A few counters indicate the number of shots *left* on the roll.) It is activated by the film-advance lever, and it resets for the next roll automatically when the back of the camera is opened.

Film-rewind crank. On the top left of the camera body is the knob used to wind the film back into its cartridge. Rewinding usually requires pushing in the film-rewind button on the bottom of the camera body, then lifting the fold-out crank handle on the top of the camera and turning clockwise. On many cameras, a firm pull upward on the rewind crank will open the camera back.

Self-timer. This lever is actually another form of shutter release. It is used to delay the exposure for a number of seconds. It is useful if you want to get into the picture yourself, and is also handy when you want to eliminate any camera movement. You can set the timer and take the picture without touching the camera even with a cable release.

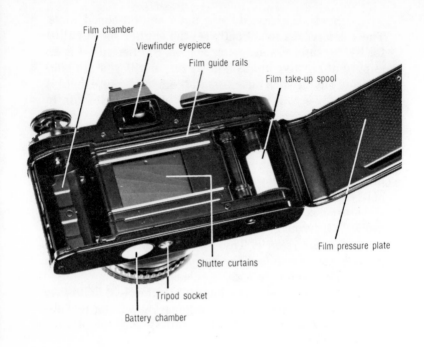

Film chamber

Viewfinder eyepiece

Film guide rails

Film take-up spool

Film pressure plate

Shutter curtains

Tripod socket

Battery chamber

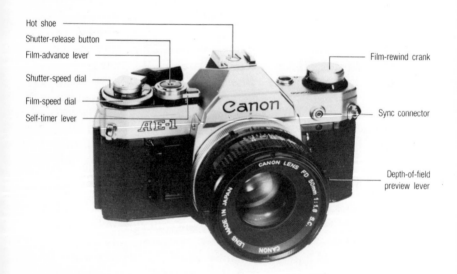

Hot shoe

Shutter-release button

Film-advance lever

Shutter-speed dial

Film-speed dial

Self-timer lever

Film-rewind crank

Sync connector

Depth-of-field preview lever

Depth-of-field preview. Regardless of the aperture you have selected, the lens remains at its widest setting until the instant before exposure. The depth-of-field-preview lever (or button, on some models) allows you to stop the lens down to the taking aperture so that you can see the depth of field that will be produced by the aperture you have selected. (Depth of field will be covered fully in Chapter 2.)

Hot shoe. The majority of SLRs have a hot shoe fitting on the top of the camera so that when a flash unit is mounted, it makes direct electrical contact between the flash and the shutter mechanism and synchronizes the flash with the opening of the shutter.

Sync connectors. An additional outlet for electrical connection and synchronization of a flash is found on most SLRs. These flash terminals are found on either the front or the side of the camera. Connectors marked "X" are always used for *electronic* flash. Check your instruction manual for the type of *flashbulbs* required with any "M" or "FP" sync connection. Also check for shutter speeds to use with electronic flash or with bulbs.

Lens-release button. This button is used to unlock the camera's lens and permit its removal.

Viewfinder eyepiece. On the back of the camera body is a most significant feature, the viewfinder eyepiece. This is where you look to compose and focus your photographs. Most viewfinder eyepieces are slotted to accept correction lenses, angled finders, or magnifiers.

Film tab holders, also called *memo holders* by some manufacturers. These are metal frames designed to hold one end of a film box, or some other memorandum about the film you have loaded into the camera.

Battery compartment. The compartment that holds the battery used to power exposure meters and electronic shutters is usually found on the bottom plate of the camera

body, but this may vary. Covers can be unscrewed with a coin for easy replacement of batteries. At least once a year the batteries should be changed, to avoid corrosion and prevent an inoperative meter or other camera control. *Be sure you use the correct battery.* Check your instruction manual for this information, for the wrong one will foul up the operation of your SLR.

When choosing between several SLRs, you might want to consider the cost of replacement batteries. The cells for some fully electronic cameras are relatively expensive, and if all other factors in your decision are equal, this may tip your decision one way or the other.

Tripod socket. The bottom plate of your camera also has a tripod socket. This socket is used not only for mounting the camera onto a tripod, but for attaching an automatic winder or motor drive.

Battery check light or button. Battery check lights or buttons may be found in various locations on the outside of your SLR.

Meter switch. This turns the meter off when not in use. Sometimes the switch is on the bottom of the camera; sometimes it is on the top. It may be hidden inside the camera and operated by pressing the shutter release only slightly, or by moving the film advance lever to a certain position. If you can't figure out how to turn the meter on and off, check the owner's manual or ask at a camera store.

Inside the Body

The illustration of the opened back of the Pentax MX is typical of an SLR interior. It shows

Focal-plane shutter. This may be metal or special cloth, and it may open and close either vertically or horizontally to allow light to reach the film behind it. The shutter determines the amount of *time* the film is exposed to light.

When cleaning the interior of the camera, take care not to touch the shutter. The mechanism is delicate and should not be tampered with. While your SLR is stored, do not leave the shutter cocked, because springs under ten-

sion may weaken and can eventually lead to shutter-speed inaccuracy.

Film pressure plate. When the back is closed, this pressure plate holds the film in place along the *film guide rails.* The edges of the film ride on the film guide rails, the tracks that run above and below the rectangular opening.

Film chamber. The film cassette, or magazine, or cartridge as it may be called, fits into this compartment. To load, pull up the rewind knob and insert the cassette into the compartment, spool end downward. Then point the film leader strip at the *film take-up spool* on the right. The take-up spool has slots into which you insert the leader. Advance the film, using the *advance lever. Be sure to advance the film far enough, so that the perforations on both edges of the film are engaged with the sprockets next to the take-up spool.* Close the back, and take up any slack in the film by turning the rewind knob clockwise gently until you feel a *slight* tension. Then advance the film another two frames. *Watch the rewind knob revolve;* if it doesn't, the film may not be advancing. When this happens, open the back and check all sprockets for correct contact connections.

If you get into the habit of checking for rewind knob tension you'll never experience the shock of discovering that the film wasn't engaged properly and never traveled through the camera.

Also inside the camera body, easily visible when the lens is removed, is the *mirror.* The mirror is extremely delicate and should *never* be touched. Ordinary mirrors, such as the ones you have at home, are coated behind glass. Mirrors used in your SLR are front-coated and are easily damaged. Fingerprints are impossible to remove. It is best not to try to remove dust from the mirror yourself. Should the mirror ever hang up or malfunction, do not attempt to fix it yourself. Take it to a camera repair shop.

While looking into the front of your camera body, you may also see connections for camera-to-lens controls. These operate the lens aperture, and perhaps provide information to the exposure meter or viewfinder. These connections may be mechanical, in which case you will see

little levers extending from the innards of the body, or they may be electrical, in which case you will only see tiny contact points. Resist the urge to wiggle those levers; their alignment is important.

EXPOSURE CONTROLS

In order to understand SLR exposure systems, we must first discuss fundamental differences in the methods of exposure control. Then we will see how the meter's information is displayed in the viewfinder.

Good exposure for all your photographs depends upon the film receiving the correct amount of light. If the film receives too much light, pictures will be pale or washed-out; too little light and pictures will be dark and muddy-looking. There are two controls on your SLR that determine the amount of light reaching the film; the shutter speed and the aperture, or *f*-stop. Shutter speed determines the *amount of time* light passes through the lens to expose the film. The aperture determines the *quantity* of light. The exposure meter in your camera reads the total amount of light the film receives according to both settings. It is up to you to choose the combination of shutter speed and aperture that best suits each of your picture situations. More about these options in Chapter 3.

There are several SLR exposure systems available, and if you are contemplating purchasing a new camera, you should consider the advantages of each.

Manual or Match-Needle

On manually operated models, you, the operator, must set both the shutter speed and the aperture. Many SLR exposure systems use a *match-needle* which requires you to align two pointers which are seen when looking into the viewfinder. Other cameras use LED's (light emitting diodes) which are tiny lights that indicate over, under, or correct exposure. Whichever indicator is used, you must manually adjust shutter speeds and/or *f*-stops to obtain correct exposures.

16

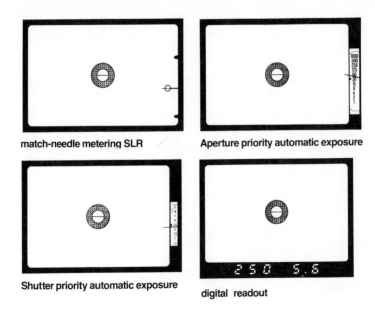

match-needle metering SLR

Aperture priority automatic exposure

Shutter priority automatic exposure

digital readout

The manual exposure system has been around for a long time. I've used it for some ten years now and have found it dependable and accurate. This system is generally the least expensive, so if price is a major consideration, you might start here.

Automatic: Shutter-Preferred

A shutter-preferred (or shutter priority) automatic system means you set only the shutter speed. The camera adjusts the aperture. Advocates of this system say that only the photographer can judge the proper shutter speed for each particular circumstance.

Automatic: Aperture-Preferred

With this system, you set only the aperture, and the camera automatically adjusts the shutter speed. Fans of this system like the possibilities of more variables in shutter speed; electronic shutters are not confined to only those speeds marked on the dial, but may shoot at intermediate speeds. There are far more aperture-preferred cameras

available because you may use older lenses with the automatic bodies.

Some very sophisticated cameras permit you to select either manual mode, shutter-priority or aperture-priority. Be sure, however, that you will need these extra choices, because they will add quite a bit to the cost of the camera.

With any automatic system, there may be times when you will want to reject the advice of your meter, so be sure you have the option of shutting off automatic features and operating your SLR in the manual mode.

VIEWFINDER SYSTEMS

To the novice photographer, a look into a modern camera's viewfinder may reveal a bewildering collection of concentric rings, blinking lights and numbers. Just as the features vary on the dashboards of automobiles, there is a wide variety of viewfinder designs. A viewfinder that is easy to understand and use is a factor in choosing your SLR.

The viewfinder serves three functions. First, it shows you what *subjects* will be seen by the camera's lens and thus included in the final photograph. Second, it provides visual aids so you can check the *focus* of the lens. Finally, most modern SLR viewfinders display *exposure* information.

Viewfinder Variables

Focusing screens. The focusing screen is a small piece of transparent plastic inside the camera. This is where you will see the image when focusing the lens. Devices on the focusing screen to make focusing easier will vary; the most common are the split-image and the microprism. Frequently, you will find both on the same screen, as in the PM screen in the illustration. As with many other camera features, the choice of microprism or split-image is one of personal preference. Try both before you buy.

18

Many makes and models of SLR's have interchangeable focusing screens. Some you can change yourself; others must be changed by a factory service representative. If you intend to use your SLR for photographing the stars or for critical architectural work, or with extremely long telephoto lenses, for example, you might want the availability of these special screens. A typical selection of screens and their applications are shown in the illustration.

Exposure read-outs. Some SLRs display exposure information within the image area on the focusing screen; others place it outside of the image area. The illustration shows four exposure readouts by Canon, but there are many variations, and there is no system that is ultimately better than another. Some photographers don't like constantly blinking lights; others do not want needles intruding into the image area. The style you choose is not important, as long as you understand it.

Finder Accessories

Waist-level finders. If your camera has a removable finder dome, you can use a waist-level finder. This finder allows you to look down at the top of the camera and see the image on the focusing screen. Such a finder is designed for copying, macrophotography, candids and other applications where right-angle viewing is preferable. It is ideal for photojournalistic shooting when the camera must be held aloft to shoot over the heads of people in a crowd, and for extremely dramatic low-angle photography where the camera is placed on the ground and eye-level viewing is almost impossible. Removable finder domes add to the cost of dhe camera, however, and you might be satisfied with a right-angle finder.

Right-angle finders. These attach to the camera's viewing window and operate like a periscope so that viewing can be from above the camera, from the side, or below.

Magnifiers. These accessories attach to the camera's viewing eyepiece to enlarge the center of the focusing screen whenever extremely critical focusing is needed. Magnifying finders are especially useful for close-up and macrophotography.

Rubber eyepiece rings. Called eye cups, hoods, or eyepieces, these accessories are made of soft rubber and attach to the camera eyepiece. They aid in more rapid and accurate focusing by conforming to the eye and blocking stray light. They are also useful if you wear glasses as they help prevent scratching of eyeglass lenses.

Correction lenses. Most SLR manufacturers offer dioptric correction lenses that fit over the viewing eyepiece. When the same power or *diopter* strength is used as that of your prescription eyeglasses, these correction lenses will permit you to use your SLR without glasses.

Other Accessories

Data backs. These units attach to the camera with the regular back removed. Information for record keeping or classification is recorded directly on the film, and can be useful for numbering or dating pictures. Both numbers and letters can be imprinted.

Motor drives and auto winders. Many SLR manufacturers now have motorized attachments for their cameras which will advance the film and cock the shutter automatically at the rate of several frames per second. Some, such as Contax and Konica, have models with built-in winders.

For fast action shots, quick sequences, or even for capturing fleeting expressions in portraiture these power winders are invaluable. If you only need the speed occasionally, they can be an expensive luxury. Before you buy, check for yourself whether or not the additional weight is going to be something you can handle comfortably.

CAMERAS AND CAMERA SYSTEMS

If you are thinking of buying your first SLR, or upgrading your present equipment, or of replacing your old equipment for something newer, the choices available are mind-boggling. In spite of what friends or camera salesmen tell you, there is, in fact, no one best camera or camera system for everyone. They are all good. Some makes and models have features you will absolutely require. They also have features that would be nice if you can afford them. Weight, ease of handling, availability of accessories, variety of lenses, and cost are items you must consider.

My personal feeling is usually influenced to a great extent by budget considerations when making recommendations. It is not necessary to buy a higher priced camera in order to get good quality; many low-priced cameras are adequate.

If budget restrictions are tight, it is wiser to choose a less expensive camera body and forego some special features, in order to buy more than one lens, or a zoom lens. Or you may prefer to buy a camera body with all the extras and settle for a less expensive lens.

Generally lenses and accessories made by the camera manufacturer are more compatible with that particular camera. If you are just starting to acquire your photographic equipment, check the availability of the lenses and accessories you will eventually need, as some accessories are available only from the camera manufacturer.

Do your research. Talk to friends, read reports on new equipment in current photo magazines, go to trade shows, gather brochures, and inspect various makes and models at your camera store. When you are in the store, and have narrowed down your selections, buy a roll of film and run it through the SLR in which you are interested. Some controls may be easier for you to use than others. Using the camera is the best test.

No matter which SLR you ultimately choose, you will be well on the way to making those exciting, spontaneous, enchanting, dramatic pictures you have always known you could make with the right equipment.

2

Lenses

Sooner or later, every serious photographer will advance beyond the stage of working with a single lens. The lens you bought with your SLR, usually a normal lens, is adequate for general photographic purposes. But when you want to move in for a tight close-up, or make a distant subject seem closer, for example, a normal lens just won't do the job for you. If you are at the point where you are frustrated because you can't capture the great shots that you see, it is time to think about adding to your lens equipment. Before you start shopping, there are a few terms you should be familiar with.

Focal Length

The focal length of a lens is expressed in millimeters, and these millimeters represent the distance from an optical point near the center of the lens to the film plane. The focal length of a lens is one of the factors that determines the size of the image on film.

If the distance remains the same from camera to subject, scene coverage increases as focal length decreases. Conversely, as focal length increases scene coverage decreases. For comparison, using a 24mm lens, the angle of view is 84 degrees; a 50mm lens covers 46 degrees; the angle of view for an 85mm is 29 degrees and a 250mm lens spans 10 degrees.

Suppose that you are shooting a scenic vista. You have surveyed the possibilities with your 50mm lens; it doesn't cover as much of the scene as you'd like, and you can't move back far enough to encompass the composition you want. The solution is to switch to a wide-angle lens, which will have a shorter focal length and will increase

22

First of three photos showing the angle of coverage of various lenses. Only a few of the useful focal lengths are shown. This shot was made with a 210mm lens.

85mm lens.

28mm lens.

Left. *Only a true friend would permit this kind of photo! Bill Griffith persuaded his pal to pose while a fisheye lens was used to create this distortion.* Right. *In all fairness, the real Bruce Webb must also be shown. Photo by Bill Griffith.*

the area coverage. That exposure made, you now would like to make another picture including only a small portion of the original scene, such as a distant mountain, but with the wide-angle or normal lens it's just too far away. Now it's time to use a longer focal length lens. You should choose a telephoto lens which decreases the scene coverage and enlarges that distant mountain.

Perspective

Focal length can affect perspective, which can be defined as "the proper relative position of objects as seen by the unaided eye." To the naked eye, an object decreases in size as it recedes. To illustrate perspective, the classic example is a straight railroad track. You see that the rails are equally spaced, as are the cross-ties, but they appeal to converge with distance and vanish somewhere at or beyond the horizon. You have also seen vertical parallel lines seem to converge, as in pictures where a tall building appears to lean backwards.

Exaggerated or distorted perspective can be the result of unconventional focal length or distance from a sub-

ject. Those leaning buildings were likely shot from a close distance, using a wide-angle lens, pointed up. Another example you have seen is that of a distorted face. When photographed with a wide-angle lens the face does not appear as it does to the naked eye, but is distorted by the choice of lens and nearness to the subject. One more frequent distortion is the use of a long focal length lens to enlarge and compress. You've probably seen news shots of heavy traffic—cars, buses, trucks, and highway signs—squeezed so tightly together that you wonder whether there was ever any vehicle movement. Again, reality is distorted by the choice of focal length.

Lens Speed

The "speed" of a lens refers to the maximum light transmission possible for that lens. Light transmission is controlled by the aperture, or f-stop. A *fast* lens is one with a large maximum aperture. A *slow* lens is a lens with a smaller maximum aperture. If a lens is rated as an f/2.8 lens, it means that f/2.8 is the largest diaphragm opening for that lens. An f/4 rated lens has a maximum aperture of f/4.

Most photographers find that at least one fast lens, for those dim light situations or shallow depth-of-field shots, is a necessary part of their equipment list. An f/1.8

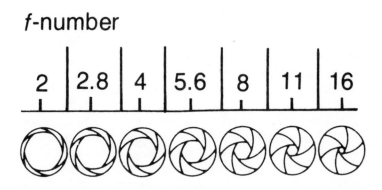

f-number

maximum aperture is standard for the 50mm lens sold with a majority of SLRs, so you probably already have one fast lens. In contemplating the purchase of additional lenses, how important is lens speed? You must consider that the faster a lens is, the heavier, bulkier, and more expensive it becomes. My wide-angle and macro lenses are $f/2.8$, the fastest lenses I own; zooms are $f/3.5$; others $f/4$ and $f/5.6$; and all perfectly adequate for my particular applications.

When you have a special requirement for fast lenses, then by all means think seriously about spending more money for them. Should your photography efforts be based primarily on another hobby of, say, cave-exploring, then you probably have a special need for fast lenses. If you're like the majority of SLR users, you'll be able to manage with something other than the fastest lenses available.

Sharpness of Lenses

All lenses are not equally "sharp." Sharpness (resolving power) and accurate color are determined by the various shapes, sizes, and placement of lens elements within the lens barrel. Modern optics produce lenses so good that concern about aberrations, or small imperfections within the lens, is practically a thing of the past. But just as there can be quite a substantial span of prices for various lenses of certain specifications, there can also be a definite span of sharpness between one lens and another in different price ranges. If an inexpensive lens gives you results you are pleased with, then it's a good lens for you. If it does not give good corner-to-corner sharpness, or color shots don't seem quite accurate, then you need to look at something better ("better" usually translates into "more expensive"). Criteria of lenses and lens results vary. The best lens for you is the one that gives you the results you want.

Maximum Aperture Sharpness. Don't trade in or sell that new lens just because your pictures do not seem quite as sharp when you're shooting wide open. Most lenses make their sharpest pictures when set about midway between the maximum and minimum apertures. That

isn't to say that you should always shoot at that middle *f*-stop. Even if wide open stops aren't quite as sharp, at least you will have pictures that you wouldn't have gotten otherwise.

Lens Coating

Lens coatings are the thin chemical films which reduce the amount of light reflected from glass surfaces. On the front surface of a lens the coating helps the lens admit more light; on interior surfaces it reduces glare and ghost images. Almost all SLR lenses now have at least a single coating, most are multi-coated. Multi-coating has proved to be even more effective in controlling *lens flare*, the internal reflections that cause ghost images, particularly when shooting into a light source. Lens flare can also cause images to be less sharp, or to lose contrast. Multi-coating is a little more expensive than a single coating, but worth it.

Lens Mounts

Interchangeable lenses may be one of the main reasons you chose a SLR. If you have not purchased your camera, you might want to consider the pluses and minuses of the two basic types of lens mounts available.

A *screw mount* lens is threaded to match threads on the camera body. Although most manufacturers are currently favoring bayonet and breech-lock lenses, there are many screw-mount lenses and cameras available on the used-equipment market, and you will find a large variety of new and used lenses and accessories so equipped. The advantage of this mount is cost; the disadvantage: starting the threads can be slow and tricky.

The *bayonet-mount* and *breech-lock* lenses have grooves which slip over a mating flange on a camera. The plus for these mounts: faster to change than the screw mount. The minus: each camera manufacturer has his own bayonet design, so all bayonet-mount lenses do not fit all bayonet-mount cameras.

Many accessory lenses are made to be fitted to your camera's mount by means of an adapter ring. Most modern

lenses and adapters will transmit the automatic dia-
phragm and exposure functions to the camera, and these
lenses are a good choice in the event you change to a cam-
era using a different mount. All that is needed is to replace
the mount adapters; your lenses are still useable.

DEPTH OF FIELD

Depth of field is the zone of acceptably sharp focus in front
and in back of a subject. Learning to control that depth of
field is one of the most important methods of making more
effective pictures. Depth of field varies tremendously de-
pending upon three factors: size of aperture; subject dis-
tance from the camera; and the focal length of the lens.

Aperture

Aperture size is the most important factor in the determi-
nation of depth of field. No matter what lens you use, *the
smaller the lens opening, the greater the depth of field.* Re-

*Both photos taken with a 50mm lens. Although only the
aperture was changed, the contrast in the depths of field
make very different impressions. The photograph on the
left was shot at f/2, the one on the right at f/16.*

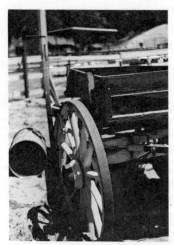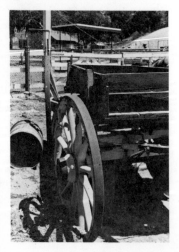

Both these pictures were taken with the same lens, the same f-stop, and the same shutter speed. Only the lens-to-subject distance was changed. The photograph on the left had a lens-to-subject distance of two feet, while the one on the right had a distance of ten feet. Differences in depth of field are quite apparent.

member that smaller apertures are represented by larger numbered *f*-stops. Keeping only the *f*-stop numbers in mind, then, *f*/11 will give you more depth of field than *f*/8; *f*/16 more than *f*/11; and *f*/22 more than *f*/16. If you need maximum depth of field for a landscape, you will use the smallest *f*-stop (highest number) possible. Should a shallow depth of field be desirable, such as in a portrait where background could be distracting if sharp, you would use a wide aperture, such as *f*/1.8, *f*/2, or *f*/3.5.

Subject Distance

The distance between the camera and the subject also affects depth of field. The precept here is: *the closer the subject, the shallower the depth of field.* For example, with a normal lens set at *f*/16 and focused at three and one-half feet, depth of field would be from three to four feet. If the same lens was focused at 25 feet, depth of field would range from about 12 feet to infinity.

Focal Length of the Lens

The final element in determining depth of field is the focal length of the lens. *The shorter the focal length of a lens, the greater the depth of field.* At the same apertures, a wide-angle lens will give more depth of field than a normal lens, and a normal lens offers more depth of field than a tele-photo lens.

Aids for Determining Depth of Field

Depth-of-field scale. Many lenses have depth-of-field scales on the lens barrel. The accompanying illustration of a Vivitar 28mm lens shows one type of scale. The focusing ring (top set of numbers showing distances in feet and meters) is focused at 3.5 feet. Just below the distance numbers is the depth-of-field scale, a set of identical aperture numbers on either side of the focus mark. The aperture ring is below the scale and shows a series of numbers representing f-stops. On this illustration, the lens is set at f/5.6. To determine the depth of field, read the distances between the marks on the scale representing f/5.6 (not shown by number on this lens, but by marks between the 4 and the 8). For this aperture setting on this lens, the zone of sharp focus would be between three and four feet.

Another type of depth-of-field scale frequently used does not show numbers on the scale. Instead, the lines of the scale are color keyed to the matching f-stop on the aperture control ring. Either type of scale is easy to learn to read. After you experiment a little with the scale on your lenses you'll wonder why you ever thought depth of field was something mysterious and difficult to understand.

Depth-of-field preview. Modern SLRs are designed so that you compose and focus on a bright focusing screen, at the maximum aperture of the lens. Because the lens does not close down to the preset f-stop until the shutter is released, you cannot see the depth of field for your chosen aperture. Most SLRs include a lever or button that, when pressed, lets you visually check the depth of field at the f-stop you have set.

30

Both subjects were photographed with the same f-stop, shutter speed, and lens-to-subject distance. Only the focal length of the lens was changed. Left. 28mm lens. Right. 210mm lens.

Either the depth-of-field scale or the preview button or lever will provide you with information sufficient for most shooting purposes. However, should you need *precise* depth-of-field measurements, most manufacturers of lenses provide them.

One other thing you should keep in mind while you're experimenting with depth of field. Good pictures require correct exposures, and if you are making changes of apertures for a particular depth-of-field result, you also need to make changes in shutter speeds. Shutter speeds and aperture work together to determine the total amount of light reaching the film. If your exposure meter tells you that for a certain situation, proper exposure is 1/125 second at *f*/5.6, and you decide that you want to open up to *f*/2 for a shallow depth of field, you must change the shutter speed to 1/1000 second. By opening up three *f*-stops, you will then need to compensate three stops on total exposure time. More information on combinations of shutter speeds and *f*-stops will be covered later.

LENSES FOR ALL PURPOSES

Sooner or later every serious photographer begins the quest for a second lens. Or even a second *and* a third lens. Which type should you buy? Rather than attempt to influence your decision, I have included below information about types of lenses available, so that *you* can decide which ones you can't live without.

WIDE-ANGLE LENSES

When you find that you are frequently standing with your back to the wall, and still can't get enough of the scene in view, it's time to consider a wide-angle lens. They can "see" more of a scene because their focal length is short. Commonly found wide-angle focal lengths are: 35mm, 28mm, 24mm, and 21mm. You may find other sizes; focal lengths of less than 21mm are considered superwide or fisheye. Wide-angle zooms are also available, and will be discussed in the section on zoom lenses.

Three characteristics distinguish wide-angle lenses. First, they have a wide angle of view. This allows you to include in the photo more of a scene than you could with a normal lens. These short focal lengths are extremely useful for photographing interiors when you are trying to include as much of the room as possible in the frame. Home decorating magazines make extensive use of photos made with wide-angle lenses. Group shots, sweeping panoramas, overall views—there are many situations where a wide field of view is needed.

The second characteristic of these short lenses is to change perspective. Extreme-wide-angle lenses distort the spatial relationships between objects and can make things close to the camera seem abnormally large.

Lastly, increased depth of field is an important characteristic of wide-angle lenses. Whenever there are both foreground and background objects that must be kept sharp, a wide-angle lens is a good choice.

Extreme-Wide-Angle and Fisheye

Extreme-wide-angle lenses increase distortion of straight lines when the camera is tilted slightly, and you will find that the walls of buildings lean in toward the center of the frame and look like they are falling over backwards when photographed with these lenses.

Fisheye lenses are very wide, and have very short focal lengths, usually less than 18mm or so. Some fisheye lenses are available as short as 6mm and, with a viewing angle of 220 degrees, you must be careful to keep yourself out of the picture! Fisheye adapters are also available. They attach to your normal lens like a filter. Images may not be of top quality, but you can have a lot of fun at a low price.

How to Choose a Wide-Angle Lens

The most popular, and perhaps most useful wide-angle focal lengths are 35mm and 28mm. Many photographers use these commonly in place of their 50mm lenses. The 35mm lens' "vision" closely resembles our own. The 28mm takes in a little more of the scene and you can use a small aperture and rely on depth of field to keep things sharp without constant re-focusing. Twenty-four and 21mm lenses must be used more carefully because of the size distortion.

As with most lenses, you will pay more for faster ones (those with wider maximum apertures) so be sure that extra f/ stop is worth the additional sum.

TELEPHOTO LENSES

Telephoto lenses have longer focal lengths and are the ones that "reach out" to grab distant objects. With a narrow angle of view, telephoto lenses have minimal depth of field, and reduce depth perspective, making near and far objects seem much closer than they are in reality.

The narrow angle of view allows these lenses to magnify distant objects, and to maintain greater lens-to-subject distances in close-up and macro work. The com-

pression of depth perspective makes it possible for you to make highways look more crowded than they are already, and to bring distant mountains closer to your campsite. Distracting backgrounds are easily thrown out of focus when wide apertures are used with long lenses.

Useful Focal Lengths

Long lenses are those with focal lengths from 75mm to 135mm. These are very useful for portraiture, when you do not want to distort the perspective of the face, or when working too close to your subject might be distracting. Sports and animals frequently require longer lenses, and those up to 200mm are fairly easy to hand-hold. Lenses above 200mm are useful for photographing animals in the wild and sporting events where you are some distance from the players. Lenses above 500mm are almost always special purpose lenses. Although they are expensive, heavy, and nearly impossible to hand-hold, they can produce spectacular images.

In the 500mm range and above, there are special mirror lenses, which are made in the same design as some reflecting telescopes. This design allows long focal lengths to be packaged in smaller mounts, and with less weight.

Using Telephoto Lenses

When using telephoto lenses, camera movement is magnified. Therefore you must be careful to hold the camera steady during exposures. A rule of thumb for hand-holding long lenses is to use the number that represents the focal length of the lens as the slowest shutter speed to be used with that lens. For example, a 200mm lens should not be hand-held at less than 1/250 sec. A 135mm lens should not be hand-held at less than 1/125 sec.

This is a flexible generalization, however, and if you are on a moving platform such as a boat or car, you may need faster speeds. If you are stationary and can steady yourself against a tree or building, you may be able to use slower speeds. For maximum sharpness, use the

fastest speed you can. When slow speeds are necessary, put the camera on a tripod.

Buying Telephoto Lenses

Long focal length lenses are sometimes less expensive than other types of lenses. This is because many designs require simple optics and mountings. On the other hand, as with other lens focal lengths, those of better quality and wider maximum apertures will cost more. Some bargain priced lenses can produce surprisingly sharp images and you might try one of these if your need is infrequent. Don't expect the very cheapest to have the same lens quality as their higher priced competition. Inquire about testing the lens on a trial basis before buying.

ZOOM LENSES

Zoom lenses are rapidly becoming the most popular optics in SLR photography, and it is easy to see why. Zooms are versatile. They allow you to select any focal length within their range, are quick to use, and are economical, too.

There are two types of zoom lenses. Those that maintain image focus as you change the focal length are true zooms. These lenses are best focused by zooming out to the maximum focal length, focusing, and then setting the zoom adjustment for the needs of the scene. The other type, although still called a zoom, is really a variable-focal-length lens. A variable-focal-length lens will not maintain sharp focus as you change the focal length. You must set the focal length first and then focus.

True zooms are more common and are preferred by many because critical focusing is easier. Both types perform well when properly used; just be sure you know what type you are working with.

Zoom Ranges

Zooms are available in many ranges. Most common are those that start at about 80mm and zoom out to about 200mm. There are mid-range zooms that run from 43mm to

86mm, and wide-angle zooms that start at 28mm to 35mm and can become moderate telephotos at 60mm to 105mm. There are even monstrous zooms that start at 300mm and go to 600mm. Many zoom lenses have close-focusing capability, and this is a very useful option.

Weigh the Advantages

Zooms may sound like the answer to all of your lens needs, and they just may be, but first, look at the pros and cons.
Advantages
- Many focal lengths in one optic
- Close-up capability possible
- Change focal length faster than changes lenses
- Easier and cheaper to carry one lens than many
Disadvantages
- Slow (small maximum aperture), difficult to use in low light
- Heavier than fixed focal length lens
- More prone to flare
- Not always as sharp as fixed lens
- Often require large filters.
In any event, many photographers, from pro to beginner, find zoom lenses ideal for their needs.

MACRO LENSES

Macro lenses allow you to make extreme close-ups of your subject without any accessories. Most of these lenses can also be used for photography of distant subjects, but they are designed for prime optical performance in the close range. If you will be doing much close-up work or slide duplication, you should consider one of these lenses. A complete discussion of macro lenses is included in Chapter 8.

SPECIAL-PURPOSE LENSES

In a book such as this, it is impossible to cover every type of optical system made, but there are two special-purpose lenses that you should be aware of.

The first is a wide-angle lens designed to move laterally within its mount. This permits photography of buildings without the convergence of lines caused by regular wide-angle lenses. Called *perspective-control lenses* or *shift lenses*, these unusual devices hold the lens perpendicular to the building's facade, and then shift it to center the subject.

Another specialty lens is the *guide-number lens*. The aperture of this lens is geared to the focusing mount. When used with an electronic flash, this lens adjusts its aperture as you focus on your subject, so that proper flash exposure is maintained. The advent of automatic flash units have, however, made this lens virtually obsolete.

TELECONVERTERS

Although not complete lenses in themselves, teleconverters are very useful accessories. By placing a converter between the lens and the camera, the focal length of the primary lens can be extended. Converters are available to double or triple the focal length of the prime lens. With a 2X extender a 135mm lens becomes a 270mm lens. With a 3X extender the 135mm lens will become a 405mm lens.

Remember, though, that these accessories are a shortcut to longer lenses, and there is some loss of sharpness and a distinct loss of illumination. Automatic converters maintain lens-camera connections, and TTL meters will read through them.

A WORD ABOUT CHOOSING LENSES

When looking at the tremendous variety of lenses available, it is often hard to decide which one is best for you. Buying lenses is very much like buying stereo equipment or cars—a lot depends upon need, desire, and the "feel" of the merchandise.

In addition to the lenses made by your camera's manufacturer, many other quality optics are available at

Notice the sign poles at either side that seem to be falling into the picture frame. The effect of a wide-angle lens makes vertical lines appear to converge. Because of this, the building looks like it is leaning backwards. Photo by Bill Griffith.

Bill Griffith used a Rokkor-X Shift Lens to make this view of the same building from the same location. This lens is a 35mm, f/2.8 lens, and focuses up to one foot from the subject.

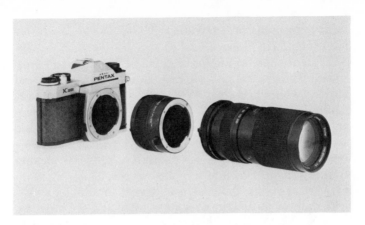

*Vivitar calls their teleconverters "Multipliers." This 2×
Matched Multiplier is shown between the camera and the
zoom lens. The lens and the Matched Multiplier are avail-
able in mounts to fit most popular 35mm SLR cameras.
Photo courtesy of Vivitar Corporation.*

prices that reflect the care and engineering that went into
them. Be wary of unusually low-priced lenses. Many of
these are preset lenses and do not have automatic dia-
phragm operation. Preset lenses require you to stop the
lens down by hand for every exposure.

Many camera stores have lenses available on a
rental basis so you can try different focal lengths before
you buy. It is not necessary to own a dozen lenses to make
good photographs. Most professional photographers do
the bulk of their work with only two or three lenses. A
good selection of focal lengths might be a moderate wide-
angle, such as a 28mm or 35mm, and a zoom in the 80-
210mm range with close focusing ability.

FINAL THOUGHTS ON LENSES

There are many small accessories made for carrying and
protecting lenses. Two you should use are lens shades or
hoods, and rear caps. If you have protected the front ele-
ments of your lenses with haze filters, you need not fumble
with front caps. Lens shades should be used to keep stray
light from striking the front of your lens and causing flare

or reducing contrast. The hood will also add to the protection of the haze filter.

Rear caps should be used when lenses are off your camera. The rear elements of many lenses are recessed and hard to clean when dirty. When cleaning lenses, use only quality tissue for camera lenses. Do not use tissues intended for cleaning eyeglasses. If you require a liquid cleaner to remove fingerprints, put a drop of cleaner on the tissue, not on the lens. This procedure prevents cleaner from running down into the lens' works. The only other maintenance you should do at home should be gentle tightening of loose screws with a jeweler's screwdriver. Lenses are precision devices and any other repairs or adjustments should be made by qualified people.

3

Exposure & Lighting

Photography. The word means "light writing"; and photographers who are visually literate know how to measure and use photography's most essential ingredient—light.

EXPOSURE

Even before we can explore the beauty and nuances of light, it is important to learn how to properly expose the film. Incorrect exposures are nearly impossible to repair after the error has been made—the best images begin with proper exposure.

Some of you may be inclined to stop reading at this point. With automatic exposure cameras, you may ask, "Why bother with understanding exposure? The machine will take care of it for me."

While it is true that automatic exposure will do part of your photographic work for you, (and do it well most of the time), you must remember that the machine can only function in limited ways. It does not have a brain that can recognize unusual conditions, nor does it have emotions that call for different interpretations of the scene. Even if you decide to delegate some of your creative decisions to your meter, you should know enough about exposure to be able to discover malfunctions while they can be corrected.

Exposure Controls

The purpose of exposure is to allow just enough light to reach the film to record the image. If there is not enough exposure, the images will be dark, muddy and indistinct. If

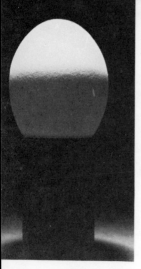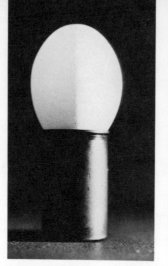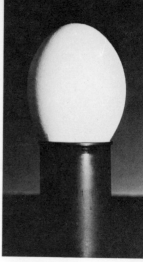

Understanding the effects of directional light is much easier after a little practice. Maureen Brown Sechrengost tried the exercise suggested later in this chapter; she used an egg, a film container, a #4 close-up lens attachment, and a single light source. Notice how the angle of the light causes the subject to appear to change shape and texture.

there is too much light reaching the film, the images will be pale and washed out. There are four factors that control exposure. They are

- Light level of the scene
- Film speed
- Aperture setting
- Shutter speed.

These four factors are interrelated; each one affects the other. Let us identify them one at a time and then see how they work.

Light level. The light level within the scene influences exposure simply because brighter scenes reflect a larger volume of light; dim scenes reflect less. Since the amount of light reaching the camera varies from scene to scene, the camera's controls act to adjust this volume to the proper level as the light enters the camera.

Film speed (ASA). Film speed means the sensitivity with which the film reacts to light. Some films need lots of light to achieve the proper exposure; other films need

only a small amount under the same circumstances. Since the requirements of different films vary, the camera's controls act to provide just enough light for the film being used. See Chapter 4 for complete information on film speed.

Aperture setting. The aperture setting is one of the two controls on the camera that determine how much light will pass through the camera and strike the film. The aperture is like the iris in your eye as it dilates or contracts in response to light.

Shutter speed. The shutter speed controls the amount of *time* the film is exposed to light.

Light and Water

To understand exposure think of light as water. If you need a certain amount of water you can get it by opening a valve for a specific time. The valve is like the aperture on your lens, and the time is like the shutter speed on the camera.

You could open the valve just a small amount and hold it open for a long time, or open the valve wide and hold it for only a short time, and in either case still get the same amount of water. The same is true with your camera's controls. You can use a small aperture and a long time, or a large aperture on a short time, and still make a correct exposure.

The way to avoid confusion when changing settings is to remember that, for a given light level. shutter speed and aperture must be changed together. Higher speeds call for wider apertures; slower speeds call for smaller apertures. Your decision as to whether to use a large or small aperture will depend upon artistic considerations that we will discuss shortly.

To help you apply the relationship between aperture and shutter speed to your camera, trace or photocopy the two discs illustrated here. Cut out your tracings and place the small disc on top of the large one. This exposure

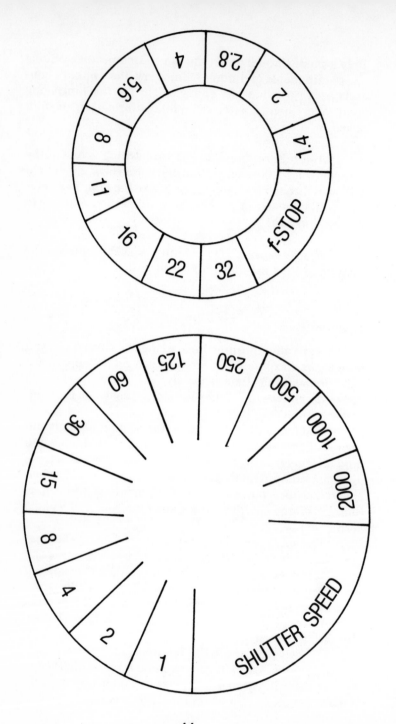

f-STOP

SHUTTER SPEED

wheel will show you all of the combinations of aperture and shutter speed that will produce the same exposure.

Suppose, for example, that the exposure called for by the meter is 1/125 of a second at f/5.6. Set 1/125 second on the large wheel opposite f/5.6 on the small wheel like this:

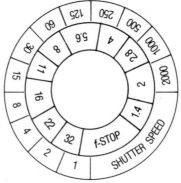

Now all of the other combinations are lined up, and any of them will produce the same exposure. Again, note that the aperture and shutter speed must both change in order to maintain the same exposure. *Be sure you are moving them in the right directions or incorrect exposures will result!* Remember also that higher aperture numbers mean smaller openings; lower numbers mean wider openings.

Under some circumstances, your choices may be limited. If you have a high-speed film, your wheel may align like this:

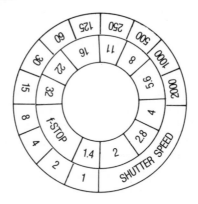

The wheel goes beyond the limits of the average SLR, and in this example, your choices with most cameras would be $f/11$ at 1/1000 second, or $f/16$ at 1/500 second. Some lenses would allow you to use $f/22$ at 1/250 second.

When getting this exposure information from a TTL meter, it is simply a matter of looking where your camera's controls have been set after adjusting the camera according to the meter. In auto-exposure cameras, the meter may have set one or both of these controls for you, but the information can usually be found in the viewfinder. Cameras that neither show you the exposure being used nor allow changes of those settings have pre-empted some of your creative control and are not recommended for those who want to take full advantage of SLR photography.

Using Equivalent Exposures

There are two reasons why you would want to use an exposure different from the one given you by the meter or the film instruction sheet. The first case is when artistic needs demand control of depth of field. Depth of field has already been covered in Chapter 2, and you might want to review that section with these exposure concepts in mind.

The other creative need is the control of motion. Look at the illustrations here and you will see how motion is influenced by shutter speed. A slow speed will allow the motion to blur, and this can often add a dynamic feeling to your photos. A fast shutter speed will freeze the motion, allowing the viewer to inspect all the details of the image.

A third option in the control of motion is to use a mid-range or slower shutter speed and pan the camera with the subject. To pan, follow your moving subject with the camera while making the exposure. This will cause the background to blur; but since your camera and the subject are moving together, the subject will remain sharp. The subject and background can both be blurred by panning a little faster or slower than the speed of the subject, or by using a very slow shutter speed such as 1/15 or below. Photos made this way can become beautiful abstractions of color and motion.

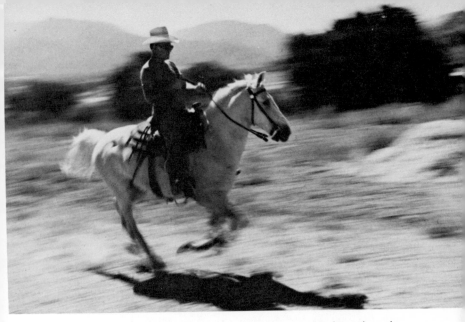

A shutter speed of 1/30 sec. and a panning motion kept the subject reasonably sharp while completely blurring the background. Shutter speed was not fast enough to stop the action of the horse's feet.

EXPOSURE METERS

Exposure meters are devices which evaluate the light level and provide suitable aperture and shutter speed combinations. It is important to remember that while most modern SLRs contain built-in exposure meters, the meter functions as a separate device, which is contained in the works of the camera.

Types of Exposure Meters

There are two types of exposure meters. One type is held at the subject and pointed toward the camera. It measures the light falling on the subject, and is not confused by very light or dark subjects or backgrounds. This type of meter is called an *incident* meter.

Reflected light meters are pointed at the subject and read the light reflected from the scene. This is the type installed in your camera, and the one we will discuss here.

What the Meter Sees

One well-known photographer and author constantly refers to "those myopic meters." How true that phrase is. Meters do not care if the subject is in focus, out of focus, light, dark, or upside down. Meters see the world as though it were a neutral gray. Regardless of where you aim your meter, it thinks it is looking at neutral gray, and will give you exposure information on that basis.

This may be fine if you are photographing a scene in which the tones average out to be neutral gray. In many cases this is true. But the meter cannot know when you are photographing something that is all white, such as a bride against a white wall. It interprets the subject as gray, and will cause it to be rendered as gray in the final photo. The same is true if you aim the meter at a dark scene, such as a black dog against dark walnut panelling. If you follow the meter's recommendation, your black dog and dark panelling will be rendered as a gray. To get the correct result, you will have to alter your meter's recommendations, and this is why it is important to buy a camera that will permit you to override the meter's commands.

Another example of myopic metering is when a dimly lit subject is centered in front of a bright background. If the meter "sees" too much of that background it will be influenced by the brightness and your subject will be underexposed.

A third example of myopic metering involves the emotional values that you want to instill in your work. Colors can be changed by minor exposure variations. Deeper, richer colors can suggest strength, boldness, and firmness. Lighter, paler colors can suggest delicacy, softness, and purity.

Also, in black-and-white, contrast is controlled by exposure and development. More exposure and less development decreases contrast; less exposure and more development increases contrast. The needs of color saturation and black-and-white contrast vary with the subject, and the effective artist keeps them under control rather than abandoning them to a machine. You will see how to handle these situations in the next few pages.

The casual portrait of Rudy Sow, French professional photographer, is a good example of a situation to be aware of when metering. The only way to keep your meter from averaging dark skin tones and bright sunlight is to move in close, take the exposure reading directly from the face, and then move back and re-compose.

Using Your Meter

Under the majority of picture-taking situations, here's how to use your through-the-lens (TTL) meter:
1. Set meter for film speed.
2. Aim camera at subject.
3. Adjust aperture and shutter speed until readout indicates correct exposure.

 With automatic exposure cameras, this last step will vary. On aperture-preferred cameras, you will set the aperture and the meter will set the correct shutter speed. On shutter-preferred cameras, you set the shutter; the meter sets the aperture. On fully automatic cameras, both shutter and aperture are set by the meter.

The Meter as Your Partner

Here are some guidelines for using meters and interpreting their readings when situations depart from normal:

 Extra-light subjects. Increase the metered exposure by about one *f*-stop (wider aperture, not higher number), or decrease your shutter speed by one speed.

 Extra-dark subjects. Decrease the metered exposure by about one *f*-stop, or increase the shutter speed by one speed.

 Backgrounds and backlight. In cases where the light is behind your subject, or the background is extra bright or dark, move in and take a close-up reading. The meter doesn't care if the image is in or out of focus. Just don't cast a shadow on your target.

 Bright sky. When there are large areas of bright sky in your scene, tilt the camera down slightly to include more foreground and make your settings. Then re-compose and shoot.

 Color saturation. You can change the color saturation by slight exposure changes. With color negative film (for prints), a half-stop over exposure increases saturation. Underexposure of color negative film is not recom-

mended, because the results will be gray and muddy. To increase saturation of transparency films, *under*expose by one half an *f*-stop. To decrease saturation, overexpose by about one quarter to one third of a stop.

When using meters under unusual circumstances, they are likely to protest your changes by indicating over or under exposure after you have made your settings and composed your image in the viewfinder, but remember, you are the one in control.

With some automatic exposure cameras, the only way you can override the meter's commands to the camera is by means of a small dial on the camera marked +1, +2, -1, -2 and so on. These markings indicate where to position the dial for an intentional exposure change.

Make test photos, and keep notes so you will understand the results. For important shots, *bracket* the exposures, making one at the indicated reading, and one slightly over, and one slightly under.

Reciprocity Failure

One last comment on exposure. The concept of equivalent exposures, that is, various shutter speeds and apertures which result in the same exposure, is valid only to a certain extent. With extremely long and short exposures, (longer than one second or shorter than 1/1000 of a second), the film does not react equally. This is called reciprocity failure. You need to increase the exposure beyond what you might otherwise use. For example, many black-and-white films can be exposed to times of one second with little loss of sensitivity. However, if the indicated time is ten seconds, you must increase the aperture by two stops or increase the time to fifty seconds. Consult film manufacturers' data sheets for the changes necessary for the film you are using.

LIGHTING

The principles of light are very simple, and the use of light is vital to the photographic statement, but learning to see light takes awareness and practice. In this chapter, you

will learn the principles and see how they are put to use. The practice and awareness are up to you, and the development of your visual literacy depends upon it.

FOUR CHARACTERISTICS OF LIGHT

There are four characteristics of light. They are: intensity; quality; direction; and color. All of these characteristics work together to make a complete statement. The influence of any one characteristic is subject to modification, or even reversal, by another.

Intensity

We are concerned with intensity only because it must be great enough to expose the film at an aperture and shutter speed which meet our creative needs. Intensity does not otherwise affect the visual qualities of the scene.

Here is an example: With proper exposure, a photograph made by the light from the full moon can look just like bright sunlight. Intensity has not changed the final photographic effect. A very long exposure would be required to solve this low light level problem, however, and moving objects would certainly be blurred. The effect *could* be obtained even with a small aperture for maximum depth of field, but more than likely, a wide aperture would be used reducing depth of field to a minimum.

Beyond depth of field and motion control then, the nature of the image is more strongly affected by the next three characteristics, which delineate shape, reveal texture, and control emotional impact.

Quality

Qualities of light are hard or soft. Hard light comes from a point source such as the sun, a photoflood bulb, or an electronic flash unit. Distinct shadows are a hallmark of hard light, and its nearly parallel rays emphasize texture.

The emotional connotations of hard light include such extremes as: hot, cold, strong, aggressive, angry, firm, and vibrant.

52

In her igloo in Point Hope, Alaska, a woman plucks a duck. An electronic flash was used for illumination. The flash unit was held high and to the left, so that its light fell on the woman's face much as sunlight would have done.

Soft light comes from broad sources such as the sky, a window with a northern exposure, a reflector-bounced flash or flood, or the rows of fluorescent lights in a large office or store. Shadow lines are less distinct; the light has a tendency to appear as though it is enveloping the subject. Soft light brings feelings of warmth, mellowness, and delicacy.

Direction

The direction of the light has a strong influence on the delineation of shape and texture. Directions of light are simply named; frontlight falls on the front of the subject, sidelight falls on the side of the subject, and so on. You can always tell the direction of the light by looking closely at the scene. It would be a good exercise to go through the illustrations in this book and examine the direction of the main light source. Look at how direction influences your perception of the shape of the subject. Use the accompanying examples for a start.

Frontlight. Frontlight, hitting the subject from the photographer's position, is frequently called flat light, because it tends to hide the three-dimensional nature of the subject.

Sidelight. Coming from the side of the subject, this light brings out a great deal of the three-dimensions; an important consideration when you translate reality to a two-dimensional piece of paper or film. Sidelight also shows texture, and when used this way it is sometimes called crosslight, because it rakes across the subject. Texture is photographically important because it indicates closeness and tactility. Only one of our senses is stimulated by photography, yet the sense of touch can be vicariously experienced by the skillful revelation of texture.

Backlight. This light usually comes from above and behind the subject, and falls upon its upper edges. When you look at television news programs, you will see back-

54

For more mature subjects, male or female, always use soft lighting. If you must use flash, bounce it off a nearby wall or ceiling, or use an umbrella reflector. For outdoor pictures, shoot on an overcast day or in the shade. Inside, try a window and reflector for the soft lighting which minimizes the effects of aging which none of us want to show.

light used on the news commentators. You can recognize it by the light areas along the person's shoulders and the top and sides of the head. This light sets the subject apart from the background and adds dimension.

Color

The influence of color on the photographic message is complex, and even the experts who study color perception and psychology cannot come up with a consistent set of emotional values for color.

In black-and-white, of course, the influence of color is diminished. Colors are abstracted into shades of gray, and although they can be slightly modified by film and fil-

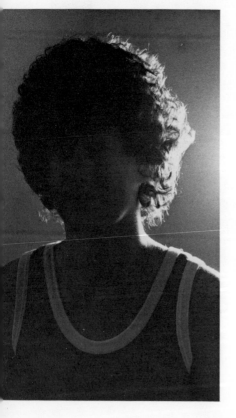

Directional backlight placed a rim of light around one side of the model's head and lightly touched the shoulders. The light was positioned above and behind the left side of the model's head.

ters as explained in Chapter 4, they are not image-making factors in their own right.

In color photography, however, the colors themselves become important compositional and emotional elements. To use this important factor to its fullest extent, you must understand the way color is recorded on film and influenced by the color of the light.

Film is made to respond to one type of light—either daylight or tungsten (ordinary room light), depending on film type. While your brain can correct what your eyes see under other light sources, the film will "see" the colors uncompromisingly. In the early morning and late afternoon, the sunlight tends to be orange and the shadows blue, in comparison to noonday light. Light from ordinary lamps (tungsten), when recorded on daylight-balanced film, is very yellow. Film "sees" mercury-vapor street lamps as blue, yellow, or other monochromatic hues and fluorescent-lit scenes as being greenish. "Indoor" film, on the other hand, will render outdoor scenes as very blue, but will be right for those events shot under tungsten lamps.

Learn to take advantage of the film's color response characteristics. Many photographers prefer to shoot only during the early or late hours to capture the warm colors. Try something different. Although you can match light sources to the sensitivity of the film (see the section on filters), so-called *correct* colors may not carry the emotional impact you are looking for.

LIGHTING EQUIPMENT

Naturally, the most convenient, and brightest piece of lighting equipment is the sun. While you can't control it as you would a flood lamp, you can plan your photography in advance to take advantage of the sun's position in the sky, and the variations of season and weather. Some architectural photographers wait months for the sun to reach the position in the sky that will light the building to the photographer's taste.

Take advantage of bad weather. Striking images are possible in storms, fog, and rain. You can protect your

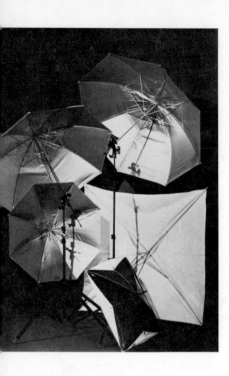

The reflectors shown here are Smith-Victor Pair-A-Sols. Two other manufacturers of umbrella reflectors are Accessories Unlimited, and Larson Reflectasol. Photo courtesy of Smith-Victor Corp.

camera by placing it in a plastic bag. Cut a hole just large enough for the front of the lens to poke through, and tape the bag around the lens, or fasten the bag with a rubber band.

Reflectors

Reflectors are very useful for adding light to shadows. Pieces of white cardboard, board covered with aluminum foil, white shirts, and commercially made reflectors all work well. To lighten shadows, place the reflector on the opposite side of the camera from the main light and angle it until you see the amount of light you want bounced into the shadows.

You can also aim a photoflood or electronic flash into a reflector for controllable soft light. With floods, read

exposures with your meter as usual. With flash, the unit's automatic exposure system will work if you can aim the sensor at the subject. If this is not possible, set the unit on "manual." Estimate the distance from the flash to the reflector and back to the subject, then check the unit's exposure dial for the proper f-stop. Add a stop and a half to your exposure to compensate for light absorption by the reflector. For maximum accuracy, make tests at different apertures and reflector-to-subject distances because reflector absorption can vary.

Floodlights

Floodlights are perhaps the best tool for learning about light. They are inexpensive, easily controlled, and you can see the result as you work. When teaching about light, I often assign students to make a series of photos of one object,

Reflectors hold flood lamps, and are positioned on either light stands or used with clamps, which can fasten to doors, furniture, or another stand or tripod. Photo courtesy of Smith-Victor Corp.

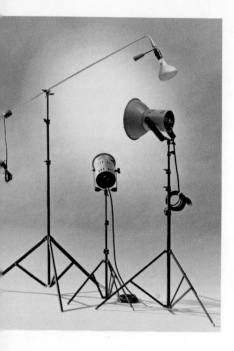

Light stands, lights, including a boom light (used in portraiture to add highlights to hair). Photo courtesy Smith-Victor Corp.

lit with one floodlight, as shown here. Try it. Explore all the positions of the light to see how shape, texture, and emotional values can be changed.

Electronic Flash

Electronic flash units are ideal for many lighting needs. They are compact, free from the heat of flood lamps, produce the correct color of light for daylight film, and the short burst of light is fast enough to stop action. On the other hand, only large studio flash units permit you to preview the lighting effect.

When buying an electronic flash, you will find that flash power is rated in several ways. The method you are most likely to encounter is the *guide number* system. This method assigns numbers to each film speed (ASA), and you will find the guide numbers for your flash unit in its

instruction book or on a dial on the unit. Divide the guide number by the distance from the camera to the subject, and the result is the aperture needed for correct exposure.

For example, suppose you have a flash that has a guide number of 60 when used with a film of ASA 125. Suppose also that your subject is ten feet away from the flash. Divide the guide number of 60 by the distance of 10 feet, and your result is an aperture of $f/6$. While you do not have $f/6$ engraved on your lens, you can set the aperture ring between $f/5.6$ and $f/8$ for the correct exposure.

Because a flash is just that—a very brief burst of light—shutter speed does not influence the exposure. Use of flash as a fill-in light source is mentioned in the problems and solutions section at the end of this chapter. Any time you are using flash, be sure your shutter is set on the proper speed, as explained in Chapter 1.

The smallest flash units may be effective over a range of six to ten feet, but if you are going to photograph large groups or distant or moving subjects, you should buy a more powerful unit. For these uses, an electronic flash with a minimum guide number of at least 80 for ASA 125 film should be satisfactory.

Automatic and dedicated flash. The exposure calculations just described are unnecessary in many flash lighting situations, thanks to the advent of automatic exposure flash devices. Small light-measuring circuits in the flash unit or in a plug-in attachment measure the light as it bounces back to the camera from the subject and turn off the flash when the proper light level for exposure has been reached.

Dedicated flash units are those which are made to link up with a specific camera brand or model. These units set the camera's shutter for the proper speed, and then receive exposure information from the camera. Some of these combinations will meter the light as it falls on the film, a feature which provides flash capability with *all* types of lenses and accessories without bothersome flash exposure calculations.

While most small flash units are made with an accessory shoe that mates with the camera, creative photog-

raphers use the flash off the camera as much as possible. On-camera flash results in flat light and "red-eye," the phenomenon that captures people with red pupils. This is a result of the on-camera position. By holding the flash to one side at arm's length, more pleasing results are obtained.

The connecting cords between the camera and flash are called *sync cords*, and they have a tendency to break or short out at the most frustrating moments, so be sure to have a spare.

One more tip about electronic flash: make test photos before using your flash with wide-angle lenses. The beam of light that the flash emits may not fully cover the lens' angle of view.

A GUIDE TO LIGHTING TECHNIQUE

Lighting is not complicated if you follow a few simple guidelines. First, set the position of the main light. This may be the sun, light coming in through a window, a floodlight, an electronic flash unit, or any other source of light. When using available light, you may not be able to set the light any place you choose, but you might be able to move your subject to change the light's effect.

Then set a secondary light to fill in the shadows on the side of the subject away from the main light. This *fill light* can be a flood lamp, reflector, or electronic flash unit. The purpose of the fill light is to put enough light into the shadows to record shadow detail. The amount of fill light is an artistic decision you will have to make. Do not try to eliminate the shadows. We see shadows in daily life and expect them in photos, too. The fill light is usually placed on the opposite side of the camera from the main light, about the same height as the lens.

You can use an automatic-exposure electronic flash to fill in when the main light is daylight. You can control the amount of fill by changing the power setting on the flash: To reduce the amount of fill, set it for *larger* apertures than you are using on the camera lens. When the

flash unit is set at the same aperture as the lens, you will get an extreme amount of fill, and the result can look unnatural.

Accent lights may be used, and these are set last. These lights highlight specific areas, and in portraiture, a backlight is often used to separate the background from the subject. See the accompanying illustrations for examples of portrait lighting.

PROBLEMS AND SOLUTIONS

There are many lighting situations with which you will have to deal, and the principles just explained should help you find some of the answers. There are problems which occur frequently, however, and some suggestions for dealing with them follow.

Remember, though, that there are no unbreakable rules. The suggestions for the problems that follow are subject to modification by your particular circumstances. Shoot first and worry later. The best education in light comes from careful observation and the awakening of your visual intuition.

Sunsets. One of the most frequently photographed of nature's phenomena. Take an exposure reading from the sky at about 45 degrees to one side of the sun—not from the sun itself! Bracket your exposures, and work quickly; sunsets don't last long. You can use the yellow and orange filters that are intended for black-and-white with color film for added effect. In black-and-white, red or green filters improve the result.

People. Overcast days and open shade are good lighting conditions for people. The light is soft and complimentary to faces. On sunny days, place people so the sun is not directly in their eyes, which would force them to squint.

Flash indoors. Bounce flash is an excellent light for indoors. Aiming the light at the ceiling or a wall produces a soft, natural-looking light. Texture-coated ceilings are best. Beware of colored ceilings when shooting color film because the returning light will be colored and influence the result. Use a rubber band to hold a small piece of white card onto the back of the flash so the card will act as a mini-reflector and kick a little light into your subject's eye sockets. Automatic exposure flash units work well when bounced as long as the sensor can be aimed at the *subject*, and not the ceiling or wall. If this is not feasible, set the unit on manual exposure, and estimate the total distance from the flash to the ceiling and then to the subject. Use the unit's exposure dial to figure the exposure and then open up two stops for light absorption by the ceiling.

Mistakes with flash. Watch out for shiny surfaces behind your subject when using direct flash mounted on the camera. The light will be reflected right back from the surface creating glare. Move the flash off-camera, or make the necessary adjustments so the flash is hitting the wall at at least a 45 degree angle.

If you allow people to back up against a wall, which they seem to always do, direct flash will cause ugly shadows on the wall. Have your subjects move at least four feet away from the wall.

Some of your flash photos will reveal close-up objects to be very light and overexposed, while distant objects are dark and underexposed. This is because the light is much more intense near the source than at a distance. To even out the exposure, move the light around to the side so the distances from the light to the various points in the scene are equal.

Fill light. Fill light levels are subject to the artistic needs of the situation. A good place to begin your experiments is at a level that places the fill light two stops weaker than the main light. When using reflectors or floodlights, close-up meter readings will show you the fill light intensity. When using automatic exposure flash, try setting your unit for two stops more than the main light exposure. This

way, the flash thinks you are using a wider aperture than you really are, and will cut the light off sooner.

Dark eye sockets. This problem usually occurs when the main light is overhead, such as high noon or in office buildings. A small amount of fill from a reflector will help lighten the shadows.

Theatres and concerts. Many theatres prohibit photography, and taking pictures is definitely bad manners during a performance. Ask the stage manager if you can attend a rehearsal or photograph a scene before or after the regular performance. At pop and rock music concerts, photography may be permitted. Take a close-up reading from directly in front of the stage if possible; or read through a telephoto lens and remember the settings to use with other lenses. In a pinch, try 1/60 at $f/2.8$ with ASA 400 film—and bracket.

Fireworks and lightning. A tripod is necessary here. Set the shutter on "B" and hold it open while the flashes occur. Allow several bursts of light to strike the same frame for a more dramatic effect. Try $f/5.6$ for ASA 125 films.

Moon and moonlight. When photographing the moon, you will need a long telephoto lens to produce anything more than a small white dot on the film. Use 1/125 second at $f/16$ for ASA 125 films, and the same speed at $f/11$ for ASA 64 films. With a full moon, try landscapes at 30 seconds at $f/2.8$ with ASA 125 film.

Street scenes and carnival rides at night. To blur the lights of the moving rides, try various exposures ranging from $f/5.6$ to $f/16$ and speeds of two to thirty seconds with ASA 400 film. With the same film speed, eight seconds at $f/5.6$ is a good starting point for photos near street lights.

4

Film and Filters

Nudes at noon, seascapes in the sun, parties on the patio, babies on a blanket, rocks in the rain; whatever your subject, there is a film that will suit your need. With so many films available, just how does one go about choosing the proper one? Before you can make an informed decision, you need to know a few things about how this light sensitive material captures images.

HOW FILM WORKS

Looking at the leader of film which sticks out of the cassette, all you see is a dark, plastic-like material with a line of perforations running down each edge. Actually, that piece of film is an acetate or plastic strip which has been coated with a mixture of gelatin and light sensitive silver salts. There are other coatings on the base material, too, but it is this light sensitive *emulsion layer* that we are most concerned with.

When the silver salts in the emulsion are struck by light, a molecular change begins. Chemical development completes this change. In processed black-and-white material (film or prints) the black and gray tones are varying amounts of metallic silver. In color material, all silver is removed during processing and replaced with dyes.

Film Speed. The chief characteristic of film is its sensitivity to light. This sensitivity is measured by film manufacturers and given numerical ratings. Ratings have long been made in terms of ASA numbers or, in Europe, by

66

DIN numbers. The new international style for giving these ratings includes both, after the letters "ISO." Here are some sample film speeds:

	ASA	DIN	ISO
High speed	400	27	400/27
Medium speed	125	22	125/22
Slow speed	32	16	32/16

Grain. Another characteristic of film is grain. The silver salts suspended in the emulsion layer form tiny clumps, and it is these clumps that you can see in even-toned areas of your photos. We call the clumps *grain.* The higher the ASA, the larger the clumps. Although color films contain no silver after processing, the presence of the clumps during dye formation results in similar grain effects.

For a period of time in the advancement of 35mm photography, visible grain, or granularity, was considered a major flaw in technique, and photographers constantly strove to reduce its visibility through special processing formulas, enlarger design, and so on. A more modern view does not disparage granularity, but recognizes it as inherent in the film.

Grain can be minimized by using slower (lower ASA) films, and in black-and-white, by the use of developers that tend to dissolve the edges of the granular clumps, and by careful control of processing times and temperatures. Grain sometimes adds to the mood of the image, and it can be enhanced by using fast films, high acutance developers, different temperatures for the various processing solutions, and high degrees of enlargement when prints are made.

HOW TO CHOOSE THE BEST FILM SPEED

Choosing the best ASA for your photographic projects is not something that can be reduced to a few easy steps. You will have to consider the pros and cons that different

With babies and young children you must shoot quickly. Faster films allow the photographer to work with the available light and therefore to be more flexible in following the active child's expressions and movements.

speeds offer, and then make a choice which is often a compromise with the ideal. Here are some points to consider:

Fast films

allow faster shutter speeds and smaller apertures; important for stopping action or getting maximum depth of field;
allow photography under lower light levels than possible with other films;
have higher grain;
have lower contrast;
are usually more tolerant of exposure and processing errors.

Medium-speed films

have less contrast than slow films, more than fast films;
have finer "grain" than fast films;
have enough speed for most daylight shooting;
are too slow for many low-light situations.

Slow-speed films

have finest "grain";
look "sharpest";
have maximum tone gradation;
require high light levels; black-and-white is extremely sensitive to variations in development.

Many photographers have found high-speed films useful for sports and action photography where high shutter speeds are required to stop the action, and for low light conditions where maximum film sensitivity is a must.

Whether it is train stations, museums, or cathedrals, photographers frequently find themselves shooting in low light situations where only fast film can do the job. A few rolls of ASA 400 film are a must in every gadget bag.

Slow-speed films are often used when maximum detail and minimum grain are important, such as in scenics. Medium-speed films are good for general outdoor photography in changing light, and when you want a choice between action-stopping shutter speeds and maximum depth of field.

There are no ironclad rules, however. The best advice is to try a roll in each speed range; and then work extensively with the one you like best. After you have learned what it will do, explore another. Experience will ultimately be your best guide.

COLOR OR BLACK-AND-WHITE

The choice between color and black-and-white may at first seem like an easy one, and, indeed, in many of your picture-taking situations, it may be. Many photographers want to capture their subjects as seen by the eye—in full color.

Consider, though, the different esthetic appeals of color and black-and-white. Color approximates what was seen by the photographer's eye; black-and-white introduces an abstract reality. Color often adds a dimension to the photographer's statement but, in some cases, may detract from it. The work of many master photographers would carry a dramatically different impact if done in color, witness the masterful work of Ansel Adams, Edward Weston, and Wynn Bullock, to name just a few.

Aside from the esthetic considerations, there are some practical ones. The grain in high-speed color films may be more objectionable than that of fast black-and-white emulsions. Color materials fade with time, particularly prints displayed in bright light; while properly processed black-and-white images have archival lives of over a hundred years. Color is more expensive to use, and it involves more variables if you do your own darkroom work.

On the other hand, color's monochromatic partner simply cannot encompass the emotional values found in the setting sun, the forest on a misty morning, or the plumage of an exotic bird.

Types of Color Film

If your choice is color, you must make another decision: Do you want slides or prints? While slides can be made from negative film, and prints can be made from slides, you will save time, money, and image quality by using film intended to give the results you want. Many manufacturers use the suffix chrome to designate film that produces slides. Color is the suffix which indicates negative film intended for prints.

Here are some popular color transparency (slide) films:

Agfachrome 64	ISO 64/19
Agfachrome 100	ISO 100/21
Fujichrome 100	ISO 100/21
Fujichrome 400	ISO 400/27
Kodachrome 25	ISO 25/15
Kodachrome 64	ISO 64/19
Ektachrome 64	ISO 64/19
Ektachrome 160	ISO 160/23
Ektachrome 200	ISO 200/24
Ektachrome 400	ISO 400/27

Some of the color print films available are:

Agfacolor (ASA 80)	ISO 80/20
Fujicolor F-II	ISO 100/21
Fujicolor F-II 400	ISO 400/27
Kodacolor II (ASA 100)	ISO 100/21
Kodacolor 400	ISO 400/27
Vericolor II Type S	ISO 100/21

A Cross Screen VI filter was fitted in front of the lens for the Los Angeles skyline shot by Bill Griffith. For exciting night views, experiment with exposures. A good starting point is a one second exposure at f/2.8 for ASA 400 film.

Also available is Eastman Color Negative 5247 ASA 100, but it can be used at ASA 200 or more. This is film used by professional motion picture photographers, and is packaged in cassettes by several distributors that advertise in photography magazines. These firms also process the film, and provide you with negatives *and* slides, and frequently, print services. This is an option worth exploring if you want both prints and slides.

Types of Black-and-White Film

All of the black-and-white films you are likely to encounter produce negatives from which prints are made. Some common black-and-white films are

Kodak Verichrome Pan	ISO 125/22
Kodak Panatomic-X	ISO 32/16
Kodak Plus-X	ISO 125/22
Kodak Tri-X	ISO 400/27
Ilford Pan F	ISO 50/18
Ilford FP4	ISO 125/22
Ilford HP4	ISO 400/27
Ilford HP5	ISO 400/27

Some special films are available such as infrared, which produces wildly distorted tonal renditions; and litho film, which produces very high contrast images and is useful for special effects or document copying. Also, if you

do your own darkroom work, the slow-speed films can be processed into black-and-white slides with a special processing kit available at most camera stores.

PUSHING FILM

It is possible to set your exposure meter on a higher ASA than recommended, and still get images. This is known as *pushing* film, or *forced processing*. You might want to do this under the following circumstances:

light level is too low for the film you are using;

higher shutter speed is needed than possible under metered conditions;

smaller aperture is needed than is possible under metered conditions;

use of filters reduces light available to film.

In effect, you are telling the meter that you have a higher ASA film than you really do. The meter gives you the exposure information on this new basis, which results in an underexposure on the film. The underexposure is then compensated for by special processing.

You will not get the same quality that you would have if you had not pushed the film, but the results are acceptable, and it is certainly better than not getting the photos at all.

Be sure to tell the processing lab what you have done. Changes of film speed should be limited to a doubling or quadrupling of the recommended speed, and *must be for the whole roll.*

CARE OF FILM

When you buy film, check the expiration date on the package. Outdated film may produce acceptable results, but increased grain, loss of speed, and color shifts can occur. When on sale, such films can be a good buy if you can be sure it has been under constant refrigeration. Shoot a test roll before buying in quantity.

Unprocessed film should be protected from extreme heat, and your refrigerator or deep freeze is a good

72

A multiple-image filter adds a bit of fun and fantasy to what would otherwise be a rather prosaic portrait. Three flood lamps with reflectors provided the lighting. The background light was low behind the subject; the main light to the subject's left; and the fill light to the left front of the subject.

place to keep unopened film for long periods. (Refrigeration also helps you to take advantage of quantity discounts. There is usually a price break on 10 or 20 rolls.) Be sure to allow several hours for the material to warm up before use.

Avoid leaving film in your car in the summer when temperatures inside the vehicle can soar well over 100 F (38 C). Also, take no chances on the felt tips of the film cassette; load your camera in the shade. In open spaces you can turn your back to the sun and cast a shadow over the camera.

Unloading a partially exposed roll. Suppose you have used a half a roll of film, and then discover that you need to change to a different ASA film, or perhaps from color to black-and-white. You can remove the partially used roll from your camera, save it, and use the second half of the roll later.

Here's how:

1. Note the frame counter's setting.
2. Rewind the film *slowly*, listening for the end of the

leader to pull off the take-up spool inside the camera. As soon as you hear the sound stop winding *immediately*.

3. Remove the film from the camera. Mark the leader with the number of frames already exposed.

When you are ready to finish the roll, load it in your camera as you would any roll of film. Then place your hand or a lens cap over the lens and advance the film. Keep watching the frame counter until you have gone two frames past the end of your previous exposures just to be sure you don't overlap that last shot. You are now ready to continue shooting.

FILTERS

Filters are light-changing devices. They allow you to modify, improve, or radically change the image before it reaches the film. Filters can reduce haze, correct color, create new colors, darken skies, reduce reflections, and create effects such as stars, fog, soft focus, and others.

Most filters are discs of glass mounted in threaded metal rings which you attach to the front of your lens. They are available in many sizes and are fitted to your lenses directly or by means of adapter rings. These rings are the best way to fit filters to a number of different lenses, rather than buying sets for each lens.

Most common filter types, as well as many special ones, are also available in gelatin squares, which are like cellophane and are easily cut to size. These are fragile, however, and frequently used filters should be of glass.

Filter Factors

When you place a filter over your lens, some of the light traveling to the film is absorbed by the filter. The amount of light absorbed differs with the type of filter, and you must make exposure corrections to compensate for this loss.

A split-field filter is useful when you want to photograph subjects that are too far apart to successfully use depth of field for maximum sharpness. In this illustration the flower in the foreground and building in the background are both in sharp focus.

So that you can determine the light loss, manufacturers provide charts with the filters which list their exposure factors. Typical exposure factors are: 2×, 4×, and 8×. The simplest way to apply these factors is to think of them as meaning that you will need to compensate for two times as much light, four times as much, and eight times as much, respectively.

When using a filter with a factor of 2×, then, you will need to give the film twice as much light as called for by a meter reading taken without the filter in place. Opening the lens up one f-stop, or slowing the shutter speed by one speed, accomplishes this. A factor of four requires a two stop or two speed change, and a factor of eight must have a *three stop* or *three speed* change.

Remember, each opening of aperture or slowing of speed doubles the amount of light, so in the last example, one stop doubles the light, two stops doubles the *new* amount for a total of four times, and opening one more stop doubles *that* amount for a total of eight times, a three-stop change.

Many photographers find it more convenient to simply memorize the following:

If the factor is,	then open the aperture
2×	1 stop
4×	2 stops
8×	3 stops

Meter readings can be taken through colorless filters such as skylights, neutral density and polarizing filters. Theoretically, you should not take readings through other types of filters, because the meter may not have the same color sensitivity as the film. In practice, I have metered through many filters for some number of years, and have had good results. Test with your filters and meter before making important pictures.

SIX IMPORTANT FILTERS

There are six basic filters which are extremely useful and should be a part of your creative equipment: skylight (or UV or haze), polarizing, neutral density, yellow, orange, and red.

Skylight Filters

Skylight or haze filters serve two functions. First, they screen out some of the ultraviolet (UV) light from distant scenic views. Photographic film is more sensitive to ultraviolet than your eye is, and the unfiltered result shows more than you might expect.

Second, these filters are almost clear, and they serve as excellent protectors for your lens. I have haze filters on all my lenses, and they are much cheaper to replace than a scratched lens element. Some photographers maintain that image quality suffers *any* time a filter is used, and prefer to use them only when absolutely necessary, but I have not been able to tell the difference between identical photos made with and without these filters.

Polarizing Filters

Once you have used a polarizing filter, you will wonder how you ever got along without one. It is easy to understand how polarizers work if you can visualize them as optical venetian blinds.

Light coming from a source such as a flood lamp or the sun is vibrating in all directions. When this *unpolarized* light strikes any non-metallic object, the light is re-

SELECTION OF FILTERS AVAILABLE FOR COLOR FILM

Filter Number	Type of Film	Increase Exposure By *f*-Stops	Uses
80A	Daylight	2	A cooling filter (reduces blue tint) which converts daylight color films for use with 3200 K lighting. (3200 K to 5500 K)
80B	Daylight	1⅔	A cooling filter (reduces blue tint) which converts daylight color films for use with 3400 K photoflood or quartz halogen lighting. (3400 K to 5500 K)
80C	Daylight	⅔	For use with clear flashbulbs.
81A	Daylight & Type B	⅓	A warming filter which prevents excessive blue with daylight color films in cloudy weather, shade, or indoors with electronic flash. Also corrects type B films (3200 K) for use with 3400 K photoflood or quartz halogen lighting.
81B	Daylight	⅓	Same applications as 81A, with warmer reults
82A	Daylight & Type A	⅓	A cooling filter which reduces excessive warmth of light in early morning or late afternoon. Also corrects type A films (3400 K) for use with 3200 K lighting.
85A	Type A	⅔	A warming filter which converts type A films for use in daylight. (5500 K to 3400 K)
85B	Type B	⅔	A warming filter which converts type B films for use in daylight. (5500 K to 3200 K)
CFD	Daylight	1	Converts daylight color films for use with fluorescent lighting. Eliminates blue-green cast which ordinarily results.
CFB	Type B	1	Converts type B films (3200 K) for use with fluorescent lighting. Eliminates blue-green cast which ordinarily results.
CC30R	Daylight	2⅓	Compensates for color distortion when using daylight color films underwater or when photographing through transparent plastic windows.

Courtesy of the Vivitar Corporation

FILTERS FOR BLACK-AND-WHITE AND COLOR FILM

Filter Name	Increase Exposure By f/Stops	Uses
1A or Skylight	0	Often used to protect the front element of the lens in addition to eliminating the excess ultra violet spectrum to which film is oversensitive. Gives more precise rendering of color in open shade or on overcast days and reduces some visible blue.
UV or Haze	0	Can be used at all times under all conditions. Eliminates ultra violet light to which film is sensitive: has no effect on any light visible to the eye. Often used as a "clear lens cap" to protect the front element of the lens.
Polarizing	1½–2	Removes or reduces reflections from non-metallic surfaces, darkens blue skies while increasing color saturation. Simply rotate the filter on its mount until the optimum effect is obtained.
ND-3 or 2× Neutral Density	1	Uniformly reduces amount of light without changing color rendition. With high-speed films in bright light, allows use of slower shutter speeds or wider apertures. ND-3 transmits 50%
ND-6 or 4× Neutral Density	2	Uniformly reduces amount of light without changing color rendition. With high-speed films in bright light, allows use of slower shutter speeds or wider apertures. ND-6 transmits 25%.

Courtesy of the Vivitar Corporation

flected in a polarized state: it is vibrating in a plane parallel to the ground or other reflecting surface.

This is the kind of light that bounces off the road and hits you in the eyes as you are driving toward the sun in the early morning or late afternoon. If you take a polarizing filter and rotate it so its venetian blinds are oriented across the vibrations of the polarized light, the polarized

White clouds are potentially interesting for a black-and-white composition, but prints are generally disappointing because the film doesn't "see" the sky as we see it. This shot was taken with no filter, and is typical of most beginners' sky pictures.

light will be blocked, and the reflections reduced. This is the principle that makes Polaroid sunglasses so effective. If you have a pair, you can take them off and rotate them to see how the reflection reduction changes.

Photographic effects. In addition to reducing glare from surfaces such as water, plate glass windows, and pavement, polarizers reduce the minute reflections that bounce off many objects in your scene. Therefore, you will get more vibrant colors, or in photographic terms, increased color saturation, when polarizing filters are used with color.

Light being reflected by particles in the atmosphere is also polarized, but only at right angles to the sun. Therefore, polarizing filters will darken skies which are 90 degrees from the sun. You will not get darker skies when photographing directly toward or away from the sun, because the sky light there is not polarized.

Polarizing filters are much easier to use than they are to read about, and you can preview the effect by looking into your viewfinder as you rotate the filter on the lens. Light loss equals about two f-stops and meter readings can be taken through polarizing filters.

SOME FILTERS AVAILABLE FOR BLACK-AND-WHITE FILM

Color	Filter Number	Increase Exposure By f-Stops	Description
Light Yellow	K-1 or No. 6	⅔	Darkens sky slightly.
Medium Yellow	K-2 or No. 8	1	Renders an accurate reproduction of daylight scenes as the eye sees them. Natural rendition of contrast between sky and clouds, flowers and foliage. Darkens sky, produces more contrast between sky and white clouds.
Dark Yellow	K-3 or No. 9	1	Additional contrast between sky and clouds.
Light Green	X-1 or No. 11	2	In portraiture, renders an exact tonal reproduction of skin as the eye sees it. Increases contrast between blue sky and clouds. Lightens foliage and darkens flowers.
Green	X-2 or No. 13	2⅓	Lightens foliage. Good for portraits in tungsten light, especially ruddy men.
Deep Yellow	G or No. 15	1⅔	Produces dramatic dark skies. Good for seascapes. Special applications in architecture photography.
Orange	O-2	2⅓	Creates dramatic contrast between blue sky and clouds, flowers and foliage. Special applications in document copying, beach & snow scenes.
Light Red	23A	2⅔	Darkens both sky & water: not recommended for portraits.
Red	25 or 25A	3	Darkens blue sky to create spectacular contrast with clouds, simulates moonlight scenes in daytime with slight underexposure, increases contrast between foliage & flowers. Special applications in document copying & with infrared film.
Blue	C5 or No. 47	3	Accentuates haze & fog.

Courtesy of the Vivitar Corporation

To add interest to cloud and sky pictures, use a polarizing filter to darken the sky and increase contrast between sky and clouds. With black-and-white films yellow, orange, and red filters will have similarly dramatic effects. In the shot above a medium red filter was used.

Neutral Density Filters

These are like photographic sunglasses. They reduce the amount of light reaching the film, and are used when you are using a very fast film in bright light and cannot stop down far enough, or have run out of fast shutter speeds. They are also useful with all other films when you want a slower shutter speed or wider aperture than otherwise possible under the prevailing light conditions.

Neutral Density filters are commonly available in densities equalling a one f-stop reduction (factor of 2×), a two f-stop reduction (factor of 4×), and a three stop reduction (factor of 8×). Other densities are available on special order, and in gelatin you can get up to a *thirteen* stop reduction. You can combine ND filters, and all meters read accurately through them.

Contrast Filters

Many colors, when converted to shades of gray, appear the same, and contrast filters are used to separate these tones. The accompanying illustrations of clouds in the sky are a prime example of this effect.

81

In black-and-white the sky photographs as very pale without filtration, because the film is disproportionately sensitive to blue light. By using filters that progress from yellow, to orange, to red, increasing amounts of the blue light are held back, and the result is darker toned skies. The white clouds remain white because they reflect yellow, orange, and red light, which is passed by the filter, resulting in white areas in the print.

Haze is also bluish, and these three filters are useful for haze reduction. Heavy haze, dust, and smog are very hard to penetrate with filters, however, and aerial surveillance photographers sometimes use infrared film for maximum penetration.

Contrast filters are available in other colors, too. Blue is used for increasing haze, and green darkens skies and lightens foliage without lightening skin tones, something that can happen with a red filter. By the way, these filters can be used with color film for strongly colored effects. Different manufacturers have different names for these filters; the accompanying chart shows the most common ones.

Other Useful Filters

Color conversion filters. If you have ever made color photos under artificial light when your camera was loaded with daylight balanced film, you know that the film does not see color the same way as your eye does. In fact, artificial light like that emitted by the tungsten bulbs in your table lamps is very yellow compared to daylight. Your eye compensates for these changes, and you do not notice the difference as much as the film does.

Therefore, when you want to use daylight color film under tungsten light, you can put on a blue 80B filter to compensate. Film designed for exposure under tungsten light can be used in daylight by placing an orange 85 filter over the lens.

Fluorescent lights create a special problem because they are deficient in red, and perfect color renditions are hard to get. There are filters which will correct this with

82

surprisingly good results but the nomenclature varies; check at the camera store or with your favorite filter-maker.

The *81A filter*. This filter corrects the slightly bluish result frequently found in photos made with electronic flash. Many photographers buy a large gelatin 81A filter and place it over their flash heads, eliminating the need to constantly juggle a lens-mounted filter when using more than one lens.

SPECIAL EFFECT FILTERS

The use of filters to create special effects is a trend which has grown rapidly with the popularity of the SLR camera. In a large part, this is due to the ability of the SLR user to preview the effect and get accurate exposure readings with TTL meters. Available to the serious filter user are matte boxes, which are large lens shades which attach to the front of the camera and allow for many types and sizes of filters to be used. Some matte box manufacturers supply dozens of special effects filters, which can be used singly or in combination with these attachments.

Useful Effect Filters

Soft-focus filters. A very useful filter is the soft-focus filter. This piece of glass is made with a reticulated surface, and it reduces some of the sharpness of modern lenses. Romantic moods are heightened by this effect, and human subjects who are showing signs of age appreciate its softening of lines and wrinkles. You can make your own soft-focus filter by daubing clear nail polish on an old sky-light filter.

Star filters. These produce star-shaped streaks around point-light sources in the scene, such as light bulbs, sun reflections from chrome bumpers, or candle flames. You can also get star effects by shooting through a scrap of window screen with the lens set at a wide aperture.

Two-color polarizers. These are polarizing filters that introduce vibrant colors as they are rotated.

There are literally dozens upon dozens of filters, and limits of space allow only a brief introduction here. It is strongly recommended that once you have mastered the basics of SLR use, explore the possibilities of filters.

SOME SPECIAL EFFECT FILTERS

Filter Name	Uses
Cross-Screen	Six-pointed stars are created by an intricate pattern of hexagons with intersecting radii. The stars are more dramatic, a more dominant element of your photographic scene.
Dual Cross	A cross screen divided, each half of the grid-star pattern etched on two independently rotating glass elements. The four-pointed stars from point light sources can be shaped to blend with other elements of the scene.
Parallel Multiple Image	A single subject repeated three or six times, its multiple images grouped in parallel succession, vertically, horizontally, or at any angle between. Multiple image 3P and 6P filters are mounted in rotating rings for complete image control.
Radial Multiple Image	A single subject repeated three, five, or six times, its multiple images radially grouped on a single frame of film. Multiple image 3R, 5R, and 6R filters are mounted in rotating rings for complete image control.
Split Field	Near and far. Beyond the limits of depth of field, this filter positions a +1 diopter close-up lens over one-half of your camera lens to focus on two widely separated subjects.
Soft (3 Grades)	Minute details, unflattering textures, blemishes distract from the subject. All fade in the romantic world of soft focus, a finely textured screen mounted in a double-threaded retaining ring. Available in three variations depending on the results you want.

SOME SPECIAL EFFECT FILTERS

Filter Name	Uses
Color Blend	Available in a variety of color combinations, red, yellow, blue. Just enough color to subdue a distracting reflection or more than enough to alter the mood of an entire scene. Attached to a polarizing filter, the color intensity is continuously variable—red to neutral, blue to neutral, yellow to neutral, red to yellow, yellow to blue, blue to red.
Half-Color	A lifeless foreground, a washed out sky, any half of the scene can be animated with color. These half-clear, half-colored filters are mounted in rotating rings to contrast or complement any scene. Available in: red/clear, blue/clear, green/clear, orange/clear.
Halo-Spot	A transparent filter that diffuses incoming light everywhere except the center portion, keeping the primary subject in focus and subduing the background by "soft-focusing." Ideal for portraiture with normal to moderate telephoto lenses.
Color-Halo	A transparent filter, mounted in a rotating ring. When pointed towards a direct or reflected point light source produces a "diffraction" rainbow-colored effect everywhere except the center portion.

Courtesy of the Vivitar Corporation

85

5

Composition

In order to make sense in verbal communications, one puts words in a certain order. In order to communicate visually, one needs to arrange pictorial subjects into certain patterns which are consciously organized. That's what *composition* is all about.

The dictionary defines composition as: "Putting together parts or elements to form a whole"; "The manner in which such parts are combined or related; constitution, make-up"; "The arrangement of artistic parts so as to form a unified whole." In photography composition is used to mean the arrangement of all the elements in a picture, the main subject, foreground, background, and secondary or supporting subjects.

How then do you go about putting your pictures together so that you come up with pleasing, or dramatic, or story-telling arrangements of subjects? Let's consider some of the ingredients and how you can use them.

RULES OF PHOTOGRAPHY

A word about "rules." A few of the old rules of photography will be mentioned, only because you'll read about them and hear about them from time to time, and you should know what they're all about. They may be of some help to you, if you're just getting started. Use them only as guidelines, not as something that is rigid or inflexible or they're likely to stifle your imagination and creativity. Try out the "rules," then *break* them with an approach that is uniquely yours.

Curves, lines, patterns, shapes, forms, and textures are abundant in nature and provide the aspiring photographer endless opportunities for perfecting his compositions.

SUBJECTS AND SUBJECT PLACEMENT

Main Subject

The main subject should be the most dominant feature in the photograph, the element that the viewer sees first. This one main subject is sometimes called the *center of interest*.

The most dominant element may be a *shape*. Shape is the simplest ingredient, the two-dimensional (height plus width) outline of an object. A person, a building, a cloud, a tree, an orange, can all be shapes that the photographer will *place* within the picture, either by physically moving that shape into position, or by choosing a point of view.

Once the shape is determined, the next look should be at the *texture*, or surface characteristic, of the subject. Texture alone can become the dominant element, and may, with proper crosslighting, produce a photograph of great visual significance.

Another dominant element may be *form*, which, in art, differs from shape in that form shows a third-dimensional aspect (height plus width *plus* depth) of an object.

A *color*, whether it "grabs" attention because of its vividness, or whether it is noted because of its subtlety, often is the most eye-catching element in a composition.

87

The woman and child of a small Guatamalan village are nicely balanced in this frame by the basket of laundry. The horizontal lines of the wall and walkway carry the eye in the same direction as the subject is looking. To have centered the subject would have destroyed the balance of the elements in this photograph. Photo by Sloane Smith.

Any of these dominant elements just mentioned, *shape, texture, form,* or *color,* can be used by itself as a main subject. They can also be used in combination with one another, but the most impressive photographs will usually be those in which the *minimum* number of elements are combined. Why is this so? The more elements present in a photograph, the more difficult it is to see and to appreciate the main subject. Many beginning students of mine have presented pictures for critique that were nothing short of chaotic—too many subjects, subjects not separated from backgrounds or foregrounds, or several subjects competing for attention. And yet most of these students intended to portray only one subject. When the main subject was isolated, and the composition simplified, the elimination of unnecessary elements resulted in photographs of much greater visual impact.

Main Subject Placement

Once you have determined what your main subject is to be, where shall you place it within the framework of your picture? Let's look at the various possibilities.

Centered subjects. One of the old "rules" of photography states that subjects should be off center. A little to the left or to the right of center is generally more pleasing. A main subject placed exactly in the center of the photograph seems a bit contrived, and in most cases, static. Of course, if your *intention* is for the static or contrived, then break this rule and do it your way. Otherwise, an off-center main subject is usually best.

Top-of-the-photo placement of the main subject is used to create an impression of strain, apprehension or tension. Placing the mass of the main subject at the bottom of the photo evokes feelings of security or stability. You must evaluate your emotional response to the main subject you have chosen, and attempt, by the placement within the frame, to convey that response to others.

Rule of Thirds. If you are very new to photography and at this point are merely looking for a place to start with your main subject placement, consider the "Rule of Thirds." Divide your photograph into thirds, both vertically and horizontally, then place your subject at any one of the four places where the lines intersect. For an example, see the accompanying photograph.

The "Rule of Thirds" is demonstrated here. The photographer has placed the subject at one of the four intersections, as recommended.

Secondary or Supporting Subjects

Every photograph need not be simple to the point of starkness to be effective. While the elemental beauty of an Edward Weston subject can hardly be surpassed, many other photographs need a secondary or supporting subject to complete the message the photographer intends. For instance, a picture of a child at play seems somehow incomplete without the inclusion of the toy the child is playing with. The entire playroom need not be shown, nor even the toybox, for the picture to say "Child With Toy." Showing the room or the toybox may so clutter the view that the small child would be "lost." In this case, one toy with the child tells the story, any more would be superfluous.

The purpose, then, of secondary or supporting subjects is to aid in telling the story you want to tell, to add to the meaning of what you want to show, or to convey an emotion. Learning to make your selections of what to include and what to leave out is not easy. It takes practice and concentration to consistently eliminate those gratuitous subjects.

FILL THE FRAME

Inexperienced photographers sometimes miss out on some potentially great pictures, not only because they've included too much, but because they're also too far away from the subject. The subject becomes lost within its surroundings. The viewer is confused because it is not readily apparent what the main subject is. The picture lacks impact because the subject fills such a tiny portion of the entire frame.

If there is one phrase that can not be repeated too often, it's this: *"Move closer!"* Take a look at your subject through the viewfinder, and when you think your picture is almost properly composed: *Stop, move closer, take another look.* When possible, keep moving closer until *everything* that doesn't belong in the composition is eliminated. Then take the picture. In other words: Fill the frame

Sometimes a photograph has both a main subject and a secondary subject. In this candid shot the secondary subject shows the main subject how to drink from a hose.

How many times have you looked at a snapshot and had the photographer point to a tiny figure and say, "that's my cousin Sally"? You can't see Cousin Sally. She's too small a part of the overall picture. Other faults in the illustration on the left include a clearly visible trashcan and a distracting background. Move close enough or use a longer lens to fill the frame with the subject. In the illustration on the right subject fills the frame, but the sunglasses and heavy shadows obscure the face, so that not all the mistakes have been corrected.

with only that which is essential. Show as much as you need and no more. Let your main subject fill a large part of the frame.

Of course there will be times and circumstances when it is physically impossible to move closer. If you're shooting from a roof-top and you've already moved to the edge, you obviously can't move any closer to the couple on the park bench across the street. They may move away before you can get downstairs. Or the light may change. Or someone may join them on the bench and put an end to the tender love scene. In order to fill the frame with only that which you feel is essential you'll need to switch to a longer focal length lens, or a zoom lens. Instead of the "View of the Park" you would have gotten with your 50mm lens, your 135mm or 200mm has captured "Young Love."

The "Snapshooter" approach. Don't be guilty of the "snapshooter" approach, which involves raising camera to the eye, and then walking backwards! You've seen it done dozens of times: The tour bus arrives, passengers disembark, cameras ready. The snapshooter lifts the cam-

Thirteen-year-old Daylene Hickey's portrait of Jenny Vath with her kitten won a 4-H Fair blue ribbon. Note that the subject fills the frame and that no unnecessary elements are included.

era to his eye, and, as the tour guide discusses the famous statue, the snapshooter walks backwards. Instead of *moving closer* to fill the frame, this not-so-mythical snapshooter does just the opposite. But then, of course, this snapshooter is happy with his pictures as long as he has some kind of an image. You, on the other hand, want the best composition, the most visual import, and the most outstanding picture possible, therefore *you* will never be culpable of using the snapshot approach.

Look at the Entire Frame

Many photographs are spoiled because the photographer did not take a good look at the *entire* frame before releasing the shutter. Objects not noticed at the time of exposure loom large and distracting in the final picture. How many times have you looked at photographs and seen a telephone pole, or a picture on a wall, or a lamp, seemingly

growing out of someone's head? A little careful attention to the entire frame before the moment of exposure can save the day.

Look through your SLR viewfinder at your subject. Place that subject within the frame wherever you want it. Then look carefully at the entire frame. *Look* at the entire frame, not just at areas of interest. The human eye notices only things which are important to the individual. Your camera's vision is objective and non-selective. It will see things you may never notice as you click the shutter. And what happens? An example:

Suppose you have hiked far into a forest and found a peaceful glen. Sunlight filters through the giant trees and the birds fill the air with their chorus. This one spot in all the world is the epitome to you of peace, solitude, and serenity.

Will you take home photographs that will recall all these thoughts? Or will you not see the empty beer cans left behind by litterbugs who had also passed this way and lingered long enough to despoil the landscape? If you have practiced enough at looking at the entire frame so that you actually see everything within it, you'll have the pictures you really wanted.

Those Bothersome Backgrounds. When backgrounds intrude or detract, it's time to do something about them. Many times it is impossible to physically move your subject or subjects, yet equally impossible to find another viewpoint so a bothersome background is eliminated. You don't have to accept the situation and make pictures that are less than they could be. Make use of the depth-of-field scale on your lens and simply throw the background out of focus. To get a shallow depth of field you may have to use a lens of a longer focal length, change to a lower ASA, use neutral density filters with medium or fast film to permit a larger aperture, or use faster shutter speeds so that proper exposure will call for a larger f-stop. Whether you use one of these suggestions, or a combination of several or all of them, get the depth of field shallow enough so that the background is no longer a bugaboo.

VERTICAL OR HORIZONTAL FORMAT

Because of the structure of the 35mm SLR, the camera seems to "fit" more comfortably when you hold it horizontally. Turning it to the vertical format is at first awkward and unnatural. All it takes, though, is a little practice and you'll soon feel equally at ease with your SLR in either position.

Unfortunately, too many beginning photographers tend to use the horizontal format exclusively. While many scenes and subjects lend themselves to a horizontal composition, there are many others that work better as a vertical.

On a class field trip, scheduled for the purpose of working on composition, students were given an assignment to photograph a standing, full-figure statue. They set up cameras and tripods, then composed their pictures. About 90% of the students originally set up for horizontal formats, which not only included the statue, but a great deal of the street scene. When the suggestion was made to

Earl Fisher was captivated by the streetlights of Wiesbaden, Germany. He originally printed the shot horizontally. Earl then tried, and liked, the vertical print because of the strong vertical line of the pole. For this picture horizontal or vertical formats become a matter of personal preference.

look at the subject as a vertical, class members found they could move closer, and fill the frame with only the statue. The subject gained greater import without the distractions of the street scene.

The next time you're out shooting, take a look at various subjects with camera in the vertical position as well as in the horizontal. You'll find that some will be better as verticals, some as horizontals, and a number that can be photographed either way. Using both formats will add variety and distinction to your work.

TOWARD BETTER VIEWING ANGLES

Horizons

Horizons and their placement have a significant symbolic effect on your overall composition. When the horizon is centered, the division is in equal parts, and has the same effect as centered subjects, static and monotonous. A centered horizon also gives rise to a feeling of conflict, since neither earth nor sky dominates.

Ground suggests heavy or earthy qualities; sky suggests light or spiritual qualities. If the horizon is placed high in the picture, less sky is shown and the effect is heavy or earthy. Placing the horizon low in the composition reveals more sky and the effect is light or spiritual. Moods and responses to photographs change with a change in horizon placement.

No matter where you decide to place the horizon, make certain that it is level. A tilted horizon can cause reactions of annoyance or uneasiness that can nullify other desired responses.

Tilted horizontals or verticals. Titled subjects indicate motion. A motorcycle photographed on the level may or may not appear to be in motion, but by tilting the camera that same motorcycle can be made to appear to be going up or downhill. A tree can be photographed with the camera held in a level position and the picture shows a normal, living, growing tree. Tilt the camera and the tree

The state flower of California, these golden poppies (Eschschulzia californica) make a dazzling display when photographed with a 70–210 zoom lens on the macro setting. Vivitar Series 1 lens; Minolta camera; Kodachrome 64 film.

Schonburg Castle rises high above the town of Oberwesel in West Germany. The picture was worth the time spent searching for a viewpoint that would include the castle, the 13th-century town, and the Rhine. Contarex camera; 50mm lens; Kodachrome 64 film.

How can you show the true size of something as large as a glacier? Here, the seal hunter in his small boat in the foreground becomes a scale for the measurement. This scene was taken while on assignment for National Geographic at Disenchantment Bay, St. Elias Mountains, Alaska with a 250mm lens on a Contarex camera; Kodachrome 64 film.

Grain fields and majestic mountains in rich color made another prize-winning photo for Delmar Dudley. Canon camera set for the greatest possible depth of field.

For this marmot of the southern Sierras (Marmota flaviventer sierrae), limiting the depth of field insures sharpness of the animal while leaving the background out of focus and therefore unobtrusive. Minolta camera; 85mm lens; Kodachrome 64 film.

A hillside of African daisies forms a colorful background for youngsters; Nicole Davis and Jenny Vath investigate the blossoms. Vivitar Series 1 zoom lens with Minolta camera; Kodachrome 64 film.

Sunsets and silhouettes
work well together, in fact
this won Delmar Dudley a
top prize from his camera
club competition. Canon
camera; Kodachrome film.

This White-lined Sphinx
Moth (Hyles lineata) was
photographed in the Mo-
jave Desert with a close-
focusing zoom lens. Min-
olta camera; Kodachrome
64 film.

Selective focus helps to isolate a subject from busy fore-
ground and background. The tiny kitten at play in the fall
leaves would have been lost in the overall view if the pho-
tographer had used the maximum depth of field. Contarex
camera; 135mm lens; Kodachrome 64 film.

seems to be falling down. If you *want* to imply motion, go ahead and shoot tilted subjects. However, if you want to make pictures that show buildings or other subjects as you usually see them, make sure that your SLR is level.

Framing

Just as you usually frame a painting to enhance it, the use of natural framing can intensify the effect of your photographs. A frame provides a supporting or enclosing border that confines the viewer's eye to the subject material within that border. When you use close objects to frame subjects which are farther away, you also create an illusion of depth.

A tree or tree branch in the foreground can add interest to a scene that might otherwise have too much open sky. An archway might effectively frame the mission bells you would like to record on film. A porch overhang can frame the patio picnic for a more interesting composition.

Whether you use framing to add depth or to draw the viewer's eye to the main subject, try this compositional

Twelve-year-old Eric Truelson used framing very effectively in his farm scene, which was shot as a part of his 4-H Club photography project.

device for some of your photos. Don't overuse it, though, since framing can become trite. When the subject calls for it, add this element of distinction.

Five-and-a-Half-Foot Syndrome

This syndrome can result in some very uninspiring pictures! What is it? It's the practice of shooting *every* picture from eye level, somewhere between five and six feet from ground level. This approach is almost universally used by the beginner, which is one of the reasons many beginners' pictures have a sameness or snapshot quality. You, as a serious photographer, are interested in pictures which will command attention for viewers and will evoke a response.

The next time you have the opportunity to spend some time with your SLR *consciously* working on the betterment of your compositions, try looking at your subject from a different angle. Walk around it. Kneel down and take a look. Climb any nearby stairs and take another look, Or, if you don't mind the stares of passersby, try the view from flat on the ground. Now try another focal length lens and go through the exercise again. With practice you'll begin to get a feel for just the right angle and focal length lens to use for that really knockout view.

Car-top shooting platform. For another approach, a car top shooting platform often comes in handy. The platforms are one way of adding additional elevation and are extremely useful for shooting over crowds, fences, and other barriers.

If you can buy a heavy duty luggage carrier for your automobile, you're halfway there with your platform. If you're also handy with tools, you can finish it yourself; or if you're a little short on patience and skill, perhaps you could talk a talented friend into lending a hand. The luggage carrier needs only the addition of a floor, either solid or slatted, bolted to the carrier frame. For the sake of safety, the floor or slats should be covered with a non-skid tape. Attach the carrier to the rain gutters of your car with toggle hooks and you're in business.

I have used a car top shooting platform for many years, on many different kinds of autos, from sports cars to

station wagons, and because of the platform I have been able to make good pictures better, as well as get shots that would otherwise not have been possible.

LEARNING TO SEE

It takes time to learn to see, but the better we're able to see pictures in the world around us, the more satisfying our slides and prints will be. Perhaps you can adapt an exercise I've been using on a photography project taught to a 4-H Club. These youngsters are in the 12-16 age bracket and eager. On one of our first shooting workshops of each year we have a game we play. At the toot of a whistle each young photographer runs in any direction he chooses. At the second toot he must stop and immediately take a picture. For a period of two to five minutes he or she must remain in that spot and *look* around. The youngsters may sit, stand, kneel or get into a prone position. At the third toot of the whistle they must take another photograph.

The few minutes of *conscious* concentration on the surrounding area have resulted in pictures that would have been missed otherwise. Many times the subject may be the same as the first quick shot, but is more interesting because it was photographed from a different elevation or angle. Often an object that was overlooked at first glance provides a more exciting subject than the obvious.

To learn to see you must learn to look for more than the obvious. The ability must be cultivated to see objects as shapes, tones, colors, textures, contrasts, light, and lines. These elements must be recognized by the mind as well as the eye before they can be arranged in your composition. Learning to see takes time and patience. The more you practice, the easier it will become.

CREATIVITY

Creativity can be defined as the ability to deal imaginatively with reality. To be creative is to use one's imagination. How do you use your imagination for such subjects as

99

The photograph on the left illustrates the use of a fast shutter speed to stop the action of the water, while the photograph on the right shows the use of a slow shutter speed. The two different renditions of the same subject each evoke unique emotional responses.

a waterfall, a bride, a face in the crowd, or a flower? Each one of these subjects can be photographed creatively in many ways, and a few suggestions might be: for a waterfall the use of a slow shutter speed, such as one second, so that the water is blurred, showing motion; for a bride use a soft-focus lens or diffusion filter to portray a misty, dreamy quality; for a face in the crowd use selective focus to make that one face sharp while the balance of the crowd scene is not critically focused; and for a flower use a macro lens or close-up attachment to fill the frame with only a detail of the blossom.

Double exposures call for creative arrangement of subjects. Special effect filters can make ordinary objects sparkle with stars or become multiple images that can be arranged and rearranged.

In the darkroom there are additional possibilities. The use of texture screens can add apparent dimensions to a print. *Sandwiching*, or printing two negatives together, creates an impressive double image. Oval, square, round, or other shaped masks (see Chapter 9, Show Off) add interest to some prints. Fascinating pictures from average photos can sometimes be made by using high contrast copy negatives.

I have mentioned some of the tools available. The attempt at creativity should not be confined to gadgets and darkroom aids, but once you make use of a few of them you'll find that your imagination will take off from there and suggest other approaches. A study of the work of famous photographers can be stimulating as a basis for exploration of ideas on your part. *Any* tool which helps to get your imagination into gear is a valid one to use. Once that imagination is at work, you are being creative.

COMPOSITION IS PERSONAL

Composition is the language of photography. It is as personal as your verbal communication. You may study all the guidelines given in this book and elsewhere, and may accept or reject at will. You may show one of your photographs to ten different people and get ten different reactions; you may even show that same photograph to one person on two different occasions and get two different reactions. What pleases, excites, or stimulates one person may have no effect on another. How you compose is ultimately your decision. If you can find no way to make your picture any better and are happy with the results, then you have achieved the desired result of pleasing yourself.

If your compositions do not fall within generally accepted patterns, but they please you, fine! You have used composition as your own personal photographic language to communicate what you have seen, felt, or imagined.

6

Travel & Scenics

That eagerly awaited vacation is about to begin, and you expect it'll be the best ever. Whatever kind of trip it's to be, the arrangements are all made, itinerary in order, wardrobe planned, and now it's time to think about your photographic equipment. What shall you take? What shall you leave at home? Should you plan to buy some of the equipment you've always felt you needed when you arrive at your destination? Let's consider these questions one at a time.

CHOOSING EQUIPMENT

What equipment shall you take? First of all, you want to take enough so that you don't miss any of the photographic possibilities you encounter. Yet you must consider your own physical capabilities in the amount of weight you can comfortably carry in shoulder bags or hand cases. Keeping your camera equipment with you can cut down the risk of theft or damage. But even more important, you *must* have a camera at hand to take advantage of picture possibilities from the moment of departure.

Equipment—Essentials

The well-equipped traveler should take:

One or more SLR cameras. Two matching bodies are recommended, not only to have an extra in the event of a malfunction, but to load them with two different kinds of film, and to interchange lenses easily.

102

A narrow medieval street lined with ancient mansions in the Gothic sector of Barcelona, Spain, is the location of this travel picture by Earl Fisher.

If the batteries in your SLR haven't been changed recently, put new ones in just before leaving home. Batteries are good for about a year, but don't take chances. It is also a good idea to take along at least one or two extra batteries.

Lenses. An ideal lens kit should include a standard, or normal lens, a wide-angle and a medium telephoto. A zoom lens or two may encompass all these focal lengths.

What standard lens do you take along if you have two 50mm or 55mm lenses, and one happens to be a macro lens? Remember that the normal 50mm is usually $f/1.8$ and the macro is $f/3.5$, so you're making a two stop sacrifice with the macro lens. Those two stops can be mighty important in low light level situations. The obvious answer would be to take both along, but if you choose not to carry two, only you can decide whether the two stops or the macro capability is most important to you.

Also recommended is the use of a UV or skylight filter on each lens. Many photographers will not agree that these filters belong on the *essential* list, but after recently having to replace one scratched and one cracked filter (at far less cost than replacing the lenses they protected), I am inclined to suggest that a filter is a necessary protection for the front element of any lens.

Film. How much should you take? Figure that you'll shoot at least one, two, or three rolls per day, and pack accordingly. If you take along all the film you'll need you won't waste any precious vacation time out shopping for film supplies. Some can be carried in your luggage and your camera bag supply replenished as needed. Film carried in luggage that will be subject to x rays should be packed in leadfoil bags, such as the Film Shield bags mentioned later in this chapter. To cut down on weight and space, remove the film from the boxes and mark the film cannisters with tape as to the kind of film each contains. If you are traveling abroad, customs officials of foreign countries aren't nearly as concerned that you're bringing in film to sell when the film is not in the original box.

As for the kind of film to take, use the film you are familiar with. You might want to include a few rolls of slower or faster speed film for unusual circumstances. A few rolls of black-and-white film should also be included. Whether you take color slide film or negative film is your own preference.

If you are traveling in tourist areas, purchasing additional film will be no problem. You may pay a little more for it in gift shops, resort areas, and airports, but it will be available. Photographic film is sold all over the

world, at least in the major cities, so if you find you're using more film than you anticipated, replenishment should not be difficult.

HEAT AND COLD

Hot Climates and Color Film

At the risk of causing you concern, you should be advised that heat and humidity *can* adversely affect film, both color and black-and-white, though color film is the most susceptible. Obvious color shifts can occur. Loss of speed and contrast can also be a result of improper handling or storage of film. If you take reasonable precautions while traveling in temperate zone summer weather you're not likely to encounter these problems. If you are traveling by car or motor home you can place film in a water-tight container and keep it in a food or drink cooler. *Never* place a camera or film in your glove compartment or under the seat above the exhaust system! Nor should you leave camera and film in the trunk of your car. Don't leave your gadget bag in full sun for hours while you build sandcastles at the beach. In other words, don't needlessly subject film to conditions that can cause problems for you.

For travel in the tropics, or anywhere you encounter high humidity, bags of silica gel in your camera case or gadget bag will absorb any moisture and prevent damage to film or equipment. If silica gel is not available, consult your camera store for a suitable alternative.

Cold Weather Cautions

Cold weather photography calls for a few extra safeguards. Fingers can quickly grow numb from handling icy cameras, and need some protection from the elements. Heavy wool gloves or mittens are fine for general cold weather wear but they will make it next to impossible to operate a camera. Wear a lightweight pair of silk or nylon gloves underneath the heavy wool ones, then slip the outer pair off when it's time to adjust camera settings, focus, or

Earl Fisher relates the circumstances surrounding this picture taken in the small town of Conques, France, "I saw this elderly gentleman looking out from his window approximately every ten seconds. He had a definite rhythm to his viewing, surveying the footpath below his window. I preset my distance and light setting, pretended to take a picture across the street, and then waited. Ten seconds went by and out he came. I turned slowly, snapped him, and then turned back to my make-believe shot. I am sure he was unaware that I took his picture."

release the shutter. Hand warmers, which are available from camping and outdoor sporting suppliers, are useful too when your fingers feel so chilled they refuse to function. A few minutes next to the hand warmers in your pockets, and you're ready to shoot again.

Condensation. Cameras and lenses must be protected from condensation. Be careful not to breathe directly onto the lens or viewfinder because the condenser moisture can freeze. Cold cameras taken into warm interiors can quickly fog up, then freeze when carried back outdoors. You can keep your cameras fairly warm by carrying them inside your coat, in a pocket, or special knapsack designed for sports photography. When you have finished shooting for the day unpack your gadget bag, wipe cameras, lenses, and other equipment with a soft, lint-free cloth. Leave the equipment out of the bag overnight while the gadget bag is left open to dry out, then re-pack the next morning.

Cold, dry weather. Cold, dry weather causes film to become brittle. Brittle film breaks easily. Static electricity also forms in dry, cold temperatures and sometimes causes streaks on your film that look like lightning flashes or chicken scratches. To avoid these problems, load, advance, and rewind film very slowly.

106

Extra care for batteries. As normal light meter batteries become colder and weaker, your exposures will become more and more erratic. Should this occur, check the exposure guide on the information sheet packed with your film instead of relying on your built-in meter. If you intend to do much shooting in colder weather, it would probably be practical for you to purchase one of the several available batteries that will tolerate the colder temperatures.

Proper exposures more difficult in bright snow and ice conditions. Since most exposure meters are "averaging" meters (see Chapter 3), they will "read" only the brightness of the snow or ice and overlook any darker subject. The darker subject will then be underexposed. If you can move in close enough so that the subject (or the subject's face) completely fills the frame, take your reading directly from the subject, then move back and compose the picture as you wish, and then shoot. Or, if you can't move in close enough, take the reading off the palm of your hand and open up one *f*-stop. Hold your hand parallel to the front of the subject when taking your reading.

Other aids. Lens shades will shield against glare. Polarizing filters cut down on reflections and glare. Ultraviolet (UV) or skylight filters reduce the bluish tone of snow scenes in color photographs.

Winter weather need not stop you from making good pictures. All it takes is a little extra effort.

OTHER ITEMS TO CONSIDER

Exposed Film

Because of uncertain mail service in many foreign countries, your best bet is to keep with you all your exposed film until you get home, then send it out for processing. However, if your journey is for more than a couple of months, and you have reason to be concerned about deterioration, there are a couple of possibilities open to you. You will find Kodak and Agfa processing labs in Europe

Whether your picture collection is of castles on the Rhine, or of your trip down the Colorado River, you can enjoy the experience over and over and over through photographs.

and elsewhere in the world, so you might want to use those. You can also check with your own embassy or consulate for the reliability of mail service from a particular country to determine whether or not you can risk mailing film to your home lab.

Accessory Essentials

For the traveler these include:

A *cable release* or two for those tripod shots you'll be taking.

Tripod. A medium weight (3 to 4 pounds) tripod will be extremely useful for those night and low-light level pictures you'll want to make. This is recommended instead of a flimsy lightweight one which may fold compactly, but also may collapse in a wind condition, or when you have a camera and telephoto lens mounted on it. A heavier tripod gets to be too much of a burden to carry around, and unless you are traveling by car and have strong shoulders, leave your sturdy but heavy tripod at home.

Lens cleaning fluid and *tissues* are a must. A small brush for dusting lenses and a larger one (approximately one inch) for both interior and exterior of your camera should also be included.

Filters can add extra interest to your photos. Take only those you're really likely to use, such as polarizing and neutral density filters. If you do not have a macro lens or a close focusing zoom lens, a set of close-up attachments or rings will come in handy.

Half Dome at Yosemite National Park has been photographed many, many times. For your vacation pictures, make an attempt to find some different approach for the typical scenics. For instance, it is unusual to find the waters of the river so still that the reflections of the mountain are clear.

A compact, automatic *electronic flash unit* will be useful. I have an inexpensive one that has given years of good service. It has a small charger that I carry in my suitcase so that I can recharge the unit overnight in any hotel or motel room. It is also practical to take along an adapter (available at your camera shop) so that electrical appliances may be used, even though electrical current may differ from that at home.

If you choose an electronic flash unit operated by batteries, make sure the alkaline batteries are fresh before you leave home, and take along a few extras.

If your budget is limited, or you merely want to reduce the total weight in your gadget bag, a *tele-converter* (sometimes called a tele-extender) is an item you should consider. A 2X or 3X converter doubles or triples the focal length of a lens and can give greater versatility to the ideal lens kit mentioned earlier. For more information on tele-converters, see Chapter 2.

The final item on the "essential" list is a *gadget bag* to hold all these other items just mentioned. You may choose either a soft, pliable shoulder bag, or a rigid case. All sizes and shapes are available. If you're buying a new one, consider a size that will hold all your present equipment *and* space for equipment you may want to add in the future. If you decide on a shoulder bag, make sure the strap is wide and comfortable, and that it's well secured to the bag itself. A little wax or soap rubbed on new zippers will assure that they work quickly and smoothly.

In the flat light of an overcast morning the building shown here warranted not even a second glance. A few hours later the sun came out and cast a striking pattern of shadows that called attention to the tiers of fire escapes.

Other Items to Consider

You may or may not want to include the next group of items in your gadget bag, but they are listed as conveniences you should consider:

 small flashlight;

 marking pen or grease pencil;

 small notebook for recording interesting bits of information to include in the slide show you'll present to your friends when you get home, or for noting exposure data in unusual situations;

 repair kit with screwdriver small enough to tighten any loose screws in your equipment;

 plastic bag and rubber bands to protect your camera and lens in bad weather situations;

 moist towelettes to make sure your hands are clean and oil-free.

Don't bother including the ever-ready, sometimes referred to as "never-ready," camera case you may have purchased with your camera. As a matter of fact, if you haven't purchased one, *don't*. They're a nuisance, adding bulk and weight, and your camera can certainly be adequately protected without one. *Do* check the camera strap, or straps, if you have more than one. If the strap is not in good condition, or isn't a sturdy one, invest a few dollars in a new one that you can feel absolutely secure about. The newer, wider straps are much more comfortable around your neck than the older, skinny models.

110

Become Familiar With Equipment

As important as the kind and amount of equipment you take along is your familiarity with it. Using any particular piece should take no more concentration than winding your wristwatch. Vacations are too short and too expensive to spend getting acquainted with new equipment. If you feel you must have additional gear, buy it well ahead of time. *Use it. Get the feel of it.* Know whether it does for you what you need for it to do. Make certain there aren't any "bugs" in it. *Then* pack it into your camera bag. This should help you answer the question, "Should I buy equipment while traveling?" The next section of this chapter should give you more food for thought on the subject.

Buying Equipment Abroad

Buying photographic equipment abroad sometimes seems very attractive to travelers.

The advantage is, of course, that you might save some money. The initial price for a camera or lens, say, in Japan or Hong Kong, will probably be less than that of the same item at home. However, with the limited duty-free allowance for goods brought into this country, you could be faced with additional charges, which could reduce the savings.

There is another important consideration, and that concerns the warranty or guarantee. If you purchase photographic equipment in your home country, a guarantee insuring the equipment is in good working order goes along with it. If you end up with a "lemon" you merely return it and the merchandise is replaced or repaired. You are protected.

If you purchase merchandise in foreign countries, the warranty may or may not be honored at home. Generally, if the manufacturer has its own distributing office here, the warranty is valid. *But*, if you buy abroad, the same merchandise that is normally handled through a distributor in this country, that distributor is not obliged to honor the warranty or guarantee of merchandise not bought here. You *could* end up with a "lemon," and have no protection.

You must decide if the gamble is worth it.

RESTRICTIONS AND PROHIBITIONS

If you're traveling to foreign countries, check with your travel agent and find out ahead of time what restrictions you will encounter. Some countries place a limit as to how much equipment you can take in. A number of countries limit the amount of film you can bring. In Mexico, twelve rolls is the limit. The Bahamas permit "a small amount for personal use." There are no restrictions on the amount but the traveler on arrival must declare and obtain a Customs receipt in Bolivia. Twenty-five duty-free rolls can be taken into India, with an additional twenty-five rolls imported on payment of duty. Canada's restrictions are to a "reasonable amount."

Foreign countries may also have restrictions on subject matter. Most will require a permit before allowing photographs of their military installations. Argentina prohibits photographs of cemeteries, bank interiors are restricted areas for Switzerland, factories may not be photographed in Sweden, bridges and beggars are taboo in India, and in Haiti you may not photograph the National Palace. If possible, find out ahead of time about restrictions in the areas you plan to travel, and save yourself frustrations and headaches.

Most museums and churches prohibit the use of tripods and flash, for good reason. Tripods *could* cause someone to trip and fall. Repeated use of a flash can cause colors in oil paintings and tapestries to fade. Museums also generally prohibit photographs of loan exhibits, since the items are not the museum's property. Photographs of works by living artists are often not permitted so as not to infringe upon the artist's rights.

Possible X-Ray Damage

Though denials are still being made, evidence seems to indicate that airport x-ray machines *do* have an adverse effect on film. X-ray damages shows up as fogging or shifts of color quality. To avoid x-ray contamination, you can request, and frequently obtain, a hand inspection of your gadget bag.

Any time you are taking pictures don't stop with one or two. Whether it's people or action shots, bracket your exposures and change lenses for near and far shots of the same subject. Film, even today, is a minor part of your vacation expenses. Shoot first, and then, if you have time to think about improvements, shoot those. Photo by Sloane Smith.

Another preventative measure is use of a product such as Film Shield bags, which are laminated with lead. A number of rolls of film, or even a loaded camera body, will fit into each reuseable bag. These bags are available from your local camera dealer and are worth the small expense. Use them for your unexposed *and* your exposed film.

REGISTRATION OF EQUIPMENT BEFORE LEAVING

To avoid problems with Customs upon your re-entry with your foreign-made equipment you need to register that equipment prior to leaving. Otherwise you may be re-

quired to pay duty on it. Take all your foreign-made equipment to the nearest Customs Office and list it on a form provided, including brand names and serial numbers. They will stamp this form, which you present to customs officials upon re-entering the country.

Or, you can avoid a trip to customs and take your insurance policy with serial numbers on it or a sales receipt covering purchase of your equipment. These too can be used as proof of ownership when you return. Be sure to duplicate these important documents before leaving, so that you if you lose them while traveling you will still have copies safe at home.

INSURANCE

With costs of photographic equipment high and going higher, you would be foolish not to take out a floater policy on your equipment. Floater coverage along with your homeowner's policy may be the least expensive for the amateur. Because some insurance companies are reluctant to handle independent camera floaters, try the agency that handles your homeowner's policy first.

Trusting to coverage under your homeowner's policy alone, without the camera floater, is not wise because, without a separate listing of equipment costs, any settlement of a claim depends upon a figure offered by the insurance company and agreed to by you. That figure may be completely unrealistic, and you may end up settling for an amount far less than your replacement cost.

If you find it necessary to take out a separate policy, which will cost more than the floater, try to get your equipment insured for *actual cost* (your original cost) or *replacement value* (cost of replacement at the time of the claim).

PICTURES ON THE GO

Your greatest pleasure comes from pictures of things, people, or places *you* are interested in. You may or may not be "turned on" by a series of shots of the Chicago Loop

at rush hour or pictures of alligators in the Everglades but many photographers have made terrific shots of these simply because the subjects were interesting to *them*. Whatever the subject matter might be, the best pictures you'll bring home will be those of subjects that evoked, in *you*, a response of some kind or another, and made you feel that you wanted to capture a memory on film.

Take the Scene Apart

Follow the lead of the thoughtful photographer, or "TP," as I'll refer to him, in your approach to travel photography. It won't be long until you notice a dramatic improvement in your pictures. A TP, whether he is a professional or amateur, is thorough. As an example, let's suppose that the shooting location is the Grand Canyon. Some photographers would rush in at high noon, grab a couple of views with a wide-angle or normal lens, perhaps another shot of a bunch of tourists smiling into his lens, and then call it a day. Not the TP.

Not the typical travel picture, but one in a series of "Guatamalan People and Places" photographed in exquisite detail by Sloane Smith.

The appearance of these hills in Death Valley change with the changing light. At high noon they are photographically uninteresting, but during the early morning or late afternoon the slanting light works to accentuate their starkness.

The TP will attempt to choose a time of day when the best light is available, usually early morning or late afternoon, so as to take advantage of form and texture accented by slanting light rays.

The TP will also:

Expose some overall views, or "the grand panorama," probably using his normal or wide-angle lens;

Use various filters to add variety and change mood;

Begin to "take the scene apart" by using longer focal length lenses to frame additional compositions of only portions of that overall view;

Vary his position, not shooting every exposure from any one angle;

Use vertical formats for some shots to avoid the horizontal postcard cliché;

Include people, or a person, to show scale;

Use his macro lens or close-focusing zoom to capture those tiny elements so often overlooked;

Wait for clouds to move into position for the picture he wants;

And finally, as the sun begins to set, the TP may even go back and do it all over again in order to portray each scene in a different mood.

116

Children are children the world
over, and the "direct" approach
worked here for Sloane Smith. This
little Guatamalan charmer giggled
and smiled for pictures both in
black-and-white and color.

His coverage has been thorough. He will have captured on film all the elements necessary to be able to
present an interesting, exciting travelogue. Viewers of
travel pictures taken by a Thoughtful Photographer will
be in for a treat instead of a treatment.

Approaching People

Most of us include, or want to include, pictures of people
in our travelogue, and in overall scenes this presents no
problem. But suppose you want to single out an individual,
perhaps an artisan at work, or an individual wearing a native costume, or a close-up view of an ethnic group? There
are a couple of approaches to photographing people and
it's up to you to decide which will work best for you.

One approach is that of "unseen observer," where
the photographer shows no apparent interest, waits for the
subject to assume some natural pose, and, using a moderate to long telephoto lens, shoots the picture. The photographer may also be pretending to focus on someone in his

own party, while actually shooting a subject some distance away.

The second approach is that of "director," where the photographer asks for permission to photograph his subject and than arranges, poses, or moves him around to make the best, or most interesting, composition. Of course it is not necessary to rearrange people after getting permission to take their pictures. Better candid shots may result from unposed subjects.

Before you use either approach, it would be wise, and polite, to find out whether local pride, custom, or religious belief will make people unwilling to be photographed. A tour guide, hotel clerk, policeman, or, in foreign countries, your own embassy or consulate, will be able to tell you. Even if there are no local prohibitions, you can show your consideration for others by asking permission first, and a friendly manner and a smile will go a long way towards obtaining that permission. In some areas it is customary to pay for the privilege of photographing someone. Usually the amount asked isn't much and you assure yourself of a willing model.

If you find those who, for any reason, object to being photographed, respect their wishes. There may be a feeling that you are invading their privacy, and perhaps you are. Poor people may resent being photographed just as you and I might be if the circumstances were reversed. Think of what your feelings would be if total strangers with cameras appeared in your neighborhood and wanted to take pictures of your daily routine. If you try putting yourself in your subject's place perhaps you will better understand the reactions of those people you'll encounter in your travels and their attitudes toward you and your camera.

LENSES AND ANGLES

How many times have you taken pictures of some awe-inspiring panoramic views and then been disappointed when you got your pictures back? You were disappointed because your slides or prints failed to show the scenes as

A Central or South American shop? Not at all. This is a bit of Olvera Street in downtown Los Angeles. When you're planning to travel, look around for local areas that approximate conditions that you'll find during your trip, and run a few rolls of film through your SLR while you hone your skills.

magnificent, or as imposing as they were when you *saw* them. Many students in my travel photography class have voiced this dissatisfaction. They bewail the fact that the mountains in the scenes look farther away and smaller than they actually were, or that the scenes seemed somehow diminished. In the students' zeal to capture half the countryside in one picture, a wide-angle lens was used. But the resulting picture was not what their eyes had seen. In order to take a picture that will appear more like your eye sees, use a moderate telephoto, such as an 85mm to 135mm lens.

There is nothing wrong in using a wide-angle lens for some scenic views, as long as you realize that distant subjects *will* appear smaller and farther away. In addition, when you want maximum depth of field, a wide-angle lens can be a good choice. However, when there are mountains in the scene, and you want them to appear closer, try a telephoto, such as a 135mm to 200mm, or longer, lens. Practice with your lenses so you will know instinctively what each lens will do. Take time to actually *look* at each scene with various focal length lenses. Then decide which lens you want to use.

Zooms Make It Easy

If you already own a zoom lens, you know the advantage it gives you in permitting the rapid change of focal lengths. If you don't own a zoom, and are contemplating the purchase of additional lenses, you should seriously consider the zooms available for your particular camera. As a photographer friend recently said, "In my opinion the photographer without a zoom today will feel deprived." My own experience with the two I own, a 35mm to 85mm and a 70mm to 210mm, has made me tend to agree. For more information, see Chapter 2.

Try Another Angle

After you've made your exposure with the focal length lens of your choice, take a look at your subject from another angle. Move to the left and look. Move to the right and look again. Get another point of view from a higher angle, and then a lower angle. Try a vertical format instead of a horizontal. Go through this entire exercise with a different focal length lens, and then another, and then still another. Work at it just a little and you'll find new and exciting picture possibilities instead of trite and uninteresting approaches. While you're at it, shoot plenty of film. Even with the increased prices, film is cheap compared to vacation costs, so expose plenty of film while you have the opportunity.

Those Difficult Shots

Low light levels. Suppose you decide to do some interior views of the beautiful old church you're visiting. The sanctuary is large and dim. Flash is virtually useless in such a large area, and may even be prohibited, as tripods usually are. Now is the time to make use of the faster film you've brought along. The ASA 200 or ASA 400 film should give you enough latitude to hand hold your SLR at large f-stops. If the light is still too dim for the pictures you want, consider *pushing* your film (see Chapter 4). If you must shoot at shutter speeds of less than 1/60 of a second, try bracing yourself against a wall, or along the top of a pew.

Pictures taken from moving vehicles are not easy, and probably won't be masterpieces. But don't hesitate to try them. For the few that will be successful, you'll be grateful for the dimension they'll add to your travel presentation.

The use of a cable or soft shutter release may let you squeeze off a shot at an extremely slow shutter speed and still avoid camera movement. Make several exposures rather than relying on only one.

When you must work with large *f*-stops, a wide-angle lens will permit the greatest depth of field, which can be important if you are attempting to include most of the interior of this old church you're photographing.

Don't overlook details, such as statues, portions of the altar, paintings, windows, or weathered doors. With a normal or moderate telephoto, shoot details as well as overall views. Try your macro or close-up attachments for extreme close-ups of some of those details. If a place you

121

are visiting is important enough for one photograph, it's important enough to also include some of those details which add to the character of the place.

Moving vehicles. Taking pictures through the windows of a moving vehicle is not the easiest nor most ideal situation, but if you have to do it to add variety to your travelogue coverage then go ahead. Use a medium telephoto lens and a shutter speed of at least 1/250 second, if you can. Hold your SLR close and parallel to the window pane and try to avoid reflections. Whether you're traveling by car, bus, train, or plane, try to avoid vibrations from the moving vehicle being transmitted to your camera by bracing your arms against your body, rather than resting them on the side wall or window.

Zone focusing. Zone focusing can be a big help on those pictures you'll be shooting from a moving vehicle, as well as in other circumstances where you'll be "shooting from the hip" and the action is such that you don't have time to focus for each exposure.

To zone-focus, utilize the depth-of-field scale on your lens. For instance, if the correct exposure is f/11, set the far distance f/11 mark of the depth-of-field scale opposite infinity. Opposite the near distance f/11 mark you will read the nearest distance at which your scene will be sharp. Some of my lenses give me the following information:

Lens	Set At	Sharp Area From	
		Close Distance	Far Distance
Wide-Angle	f/8	3.4 m (11 ft) to Infinity	
Wide-Angle	f/16	2.0 m (6½ ft) to Infinity	
Normal	f/16	3.4 m (11 ft) to Infinity	
Moderate telephoto	f/8	12.1 m (40 ft) to Infinity	
Moderate telephoto	f/16	7.6 m (25 ft) to Infinity	
Moderate telephoto	f/32	4.0 m (13 ft) to Infinity	

Run information tests with your various lenses. The depth-of-field dimensions will not be *exact*, but they will be close enough so you'll be able to get good, sharp pictures that you might otherwise miss because there wasn't time to focus for each and every exposure.

Weather influences mood, and foul weather pictures are often re-membered best simply because they are different from the usual blue sky, white cloud, perfect-day pictures.

Bad weather. Don't make the error of leaving your SLR in your hotel room or car on rainy days. You may miss some of the most outstanding pictures of your entire trip. Sunshine and blue skies produce great pictures, but when you wish to capture mood or atmosphere, be prepared to shoot on those less-than-perfect days.

As weather conditions change, be ready to capture those transformations in the scene before you. Let the fog shroud the scene in mystery, the menacing storm clouds enhance the sky, or a gentle rain add a somber note.

The accompany photo of the fishing boats which had washed ashore following the great Alaskan earth-quake of March 27, 1964 was shot during a snow storm a

few days after the quake. The dreary, dismal day depicts the desolation and destruction more vividly than would have been possible under blue skies.

Instead of bemoaning bad weather, let it work for you.

Protect your equipment. Inclement weather calls for some additional thought to protecting your equipment. Standard accessories like haze filters and lens hoods help to protect lenses from the elements and other standard items in your travel gear, such as raincoats, umbrellas, and plastic bags will also help keep water out of your equipment.

To make a handy rain shield from a clear plastic bag cut a hole in the closed end large enough to fit over your lens, for, unless you want some weird effects, avoid covering the front of the lens with the plastic. Use a rubber band to fasten the plastic bag tight to the back of the lens hood. The open end of the plastic bag will permit you to fit at least one hand inside for easy manipulation of shutter, f-stops, focusing ring, and film advance. Should you happen to get a few drops of moisture on camera or lens, wipe them dry with a soft cloth and the equipment won't suffer any permanent damage.

Travel Time Is Picture-Taking Time

Whether we're traveling around the world, across the country, or merely to the nearest park, there is an excitement involved that makes interest higher, senses sharper, and perception clearer. In the everyday world around us we sometimes fail to see the picture possibilities. But let us find ourselves in another environment with SLR in hand and the possibilities are endless!

7

Close-Up & Macro

Exploration of the world beyond the limits of your unaided eye is one of the most exciting benefits of SLR ownership. With modern equipment the complex optical and exposure problems of the past are more easily solved. You can begin with only a few simple accessories, open whole new realms of visual experience, and record them on film to share with others. Modern SLR cameras are ideally suited to this adventure. SLRs allow you to accurately compose and focus, determine exposure more easily, try many combinations of accessories, and preview the result before you make the exposure. If you would like to enjoy a new perspective with your SLR, try close-up and macrophotography.

WHAT CLOSE-UP REALLY MEANS

Close-ups, macrophotographs, photomicrographs—what a perplexing array of terms! Let's see if these words can be sorted out and defined so you will know what you are talking about and, even more important, what you are *doing* when you delve into this fascinating field.

First, you need to understand how close-ups and macrophotographs compare to their photographic subjects. The relationship is expressed in terms of a ratio, such as 2:1. The first figure is always the size of the image on the film, and the second is the relative size of the subject. In this example, the image on the film is two times the size of the subject; a true macrophotograph. If the example were expressed as 1:2, the *object* would be twice as large as its *image* on the film.

125

A bundle of sophisticated equipment is not necessary for you to be able to take pictures like this one. You can start with the camera and lens you already have. With only a modest investment, and a little practice, you'll soon be on your way to new, exciting explorations in the fantastic world of close-ups.

Close-Ups

An accurate definition of *close-up* is similar to the answer to the question, "How high is up?" Specialists in the field do have precise definitions but in this chapter, a close-up will be defined as any photograph made with more magnification than is possible with conventional lenses. For example, your 50mm lens may focus to a minimum distance of two feet. With the addition of a close-up accessory you

could move in to a few inches or less. The close-up range extends inward until the image-object ratio reaches 1:2. The range between 1:2 and 1:1 is considered the *extreme close-up* range.

Macrophotography

This term means that the magnification is such that the image on the film is larger than the object itself. The range of macrophotography is from 1:1 to about 30:1. Beyond this, you will need the aid of a microscope, and you will be making photo*micrographs*.

In this chapter, the commonly used term *macro* will be used instead of the full word *macrophotography*.

EQUIPMENT

Manufacturers provide a wide variety of close-up and macro equipment in a wide range of prices. As with almost everything else you get what you pay for. The higher-priced equipment is usually better made. However, the budget-priced gear is often fine if you are not a professional macrophotographer. Because there are so many different lens mounts and sizes, your local dealer may not know if a specific item is available. If he can't find it for you, check some of the larger suppliers that advertise in the photographic magazines.

The secret to detailed leaf veins is backlighting. In this instance the photographer placed the leaf on a light-box used for sorting slides. The same effect could be gained by taping it to a window. Photo by Maureen Brown Sechrengost.

Close-Ups and Your Lenses

Most close-up equipment uses one of your camera's present lenses as a part of the system. All focal lengths can be used, but wide-angle lenses result in distortion and short lens-to-subject distances.

More than likely your camera and lens transmit diaphragm and meter information to each other as previously explained. When using some kinds of close-up equipment, this feature may not be carried through the accessory. You will have to perform the function yourself. Camera manufacturers have foreseen this, and you can check your camera's instruction book for the procedure, which will probably be under the heading "Stop-Down Metering," or "Manual Mode."

Longer focal lengths are preferred. Focal lengths longer than normal are often used for close-up and macro work because they increase the lens-to-subject distance. This distance is important for two reasons. First, as it increases there is less distortion of the subject. You will find the same phenomenon when making portraits with, for example, a normal focal length lens compared to a telephoto. Second, when making extreme close-ups and macro images the distances can be as short as a quarter of an inch. This does not leave you much room to operate the camera's controls, place lighting equipment, or manipulate the subject. Although normal lenses produce satisfactory images, longer focal lengths increase the working distance and ease the problems.

Supplementary Close-Up Lenses

Supplementary close-up lenses (sometimes called *plus-lenses*) are probably the easiest accessories to use for photographing small subjects. The lens attaches to the camera's lens like a filter, and is like a magnifying glass in that it modifies the camera's lens for work at close range. Close up lens' strength is measured in diopters and are usually available in powers from one to ten. You will frequently find them available in sets of three, with powers of +1,

Without changing lens focal length, the author made these three different photographs of the same subject. The scene above left was shot with only the conventional lens on the camera, the one next to it with a plus one supplementary lens, and the one at bottom with a plus two supplementary lens.

+2, and +3. You can stack these lenses on top of each other to get the combined power, and if you can find one, a set of +1, +2, and +4 will give you more range.

An exciting variation of the supplemental lens is one that has been cut in half. This allows you to photograph close and distant objects in the same scene.

Some advantages of supplementary close-up lenses are:
 low cost;
 portability;
 acceptably sharp at small apertures.
 Some of the disadvantages are:
 some loss of "sharpness" (resolution);
 useful range usually limited to 1:10 through 1:3;
 some distortion of straight lines when copying flat art-
 work.
 Considering cost and convenience, supplemental close-up lenses are a useful accessory. I often carry a set for comfortable close-ups in the field.

Extension Tubes or Rings

Also sold in sets of three, *extension tubes* provide another method of image magnification. These accessories mount between the lens and the camera body, and are usually only a little more expensive than plus-lenses. In contrast to a plus-lens, however, tubes do not interfere with the optics of your prime lens, and the results are sharper.
 Tubes will bring you into the range of true macro work where images are larger than life-size, and if you decide to use them, be sure to purchase a set that will permit you to continue to take advantage of all the automatic features of your SLR.
 Some advantages of extension tubes:
 preserve optical qualities of prime lens;
 extreme magnifications beyond 1:1 possible;
 auto diaphragm connections available;
 rigid support for lens.
 On the other hand, there are some disadvantages: rigid tubes limit magnification choices; increased exposure necessary.

Bellows Units

A bellows unit is mounted like extension tubes between the camera and the lens. Behaving like an infinitely variable set of extension tubes, a bellows unit gives you max-

imum flexibility in close-up and macro work. With a normal lens, magnifications of 4:1 are possible. Some sophisticated units provide for lens swings and tilts similar to view camera controls, but it is unlikely that a beginner would need such options.

Inexpensive bellows units are common, but try to get one that will transmit the automatic diaphragm function from the camera to your lens. With an adaptor bellows units are useful for slide copying, a subject that will be covered later in this chapter.

Advantages of bellows units:
infinitely variable magnification over its range;
magnifications to 4:1 and above easily obtained;
becomes a versatile slide duplicator.

Disadvantages of bellows units:
bulky;
somewhat fragile;
usually higher cost than tubes or plus-lenses.

Reverse Adapters

Reverse adapters allow you to attach your lens to the camera with the rear end facing the subject. This alone will give you about 2:1 magnification. When using extension rings or a bellows unit for magnifications greater than 1:1, you will get sharper images by reversing the lens. This is because the lens was designed to perform with a small lens-to-film distance and a large lens-to-subject distance. At high magnifications, the distance from the subject to the lens becomes *smaller* than the distance from the lens to the film. A reversed lens restores the proper distance relationships and improves optical performance.

Reversing your lens will require you to use your through-the-lens meter in the manual or stop-down mode because the automatic connections will not be made.

A Macro suggestion. If you ever need to make a close-up photo and find you haven't got your adapters handy, you can simply reverse the lens and hold it up to the camera body by hand. The fit is usually close enough that stray light leaking between the lens and body is not a

problem. If you have a rubber lens shade, a better seal will result, and the lens-camera distance can be increased for greater magnification.

Macro Lenses

If you want the sharpest images and the tool that is easiest to use, a *macro lens* is your best choice. In almost all cases these lenses are not true macro lenses as we have defined the term. They are really close-focusing lenses; their mounts are designed to permit continued focusing to a magnification range of about 1:2. Nevertheless, they are great lenses, easy and fun to use.

In addition to close focusing, macro lenses are optically designed for good performance at close distances. They will provide sharp images across the frame, and do so without distorting straight lines when copying flat artwork. In contrast to conventional lenses, macro lenses need not be reversed for macro work up to 2:1.

Macro lenses are available in focal lengths from 50mm to 100mm and, in addition to their macro capability, they can be focused to infinity and used for distant scenes. For this reason you might want to buy one in a focal length that is not already a part of your lens inventory. If you are buying your first SLR and anticipate doing a lot of close-up work, you might buy a macro lens instead of the normal lens. You should be aware, however, that most macro lenses have a maximum aperture of $f/3.5$, while faster conventional lenses in this range are available. Also, because of the focus mount design, you must be more careful when focusing on distant subjects.

When adapted for your enlarger macros make good enlarging lenses. The shorter focal lengths keep distances between the enlarger head and the baseboard within reason.

Short-mount lenses. The requirements of macro lenses are corner-to-corner sharpness, high resolution ("sharpness"), and flatness of field. Short-mount lenses designed for use on bellows units meet these requirements and produce excellent images. The combination of a short-

132

A career in legal evidence photography is a relatively new field. Whether you are an employee of a law enforcement agency or as a civilian, the job demands an expertise in macro and close-up photography. Photo by Marty Kovacs.

mount lens and a bellows can cost less than half the price of an automatic, infinity-focusing macro lens. There are some drawbacks, though. This combination is not as sturdy as a macro lens and may not survive hardy field work. Short mount lenses do not have automatic diaphragm operation, and it would be difficult to use them on distant subjects. Nevertheless, this is a low-cost approach to excellent quality images.

Macro-Zooms

The most recent development of all is the macro-zoom lens. These lenses are an ideal solution for the photographer whose optical needs will vary from long to short and close to far. For the budget-minded, one good macro-zoom will take the place of many other lenses and save weight and bulk as well.

These lenses should correctly be called close-focusing zooms, because none of them really reach into the true macro range. Magnification usually ends at about 1:4. Some of these lenses will close-focus at any focal length in their range, an advantage when lens-to-subject distance is important. Available to fit many cameras, macro-zooms can be found at various prices. Remember, however, that there are many lens elements and mechanical parts in such a device, and low prices will mean some compromise in

133

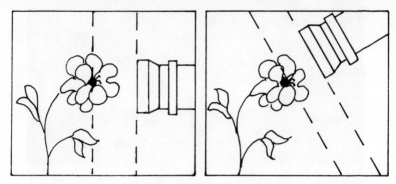

For best results with depth of field, camera and lens should be parallel to the subject. In the illustration to the right you see how not to position your lens. The illustration on the left shows the correct parallelism for maximum depth of field.

quality. To the serious macrophotographer, macro-zooms cannot compare to fixed focal length lenses for sharpness, and they are heavy and prone to flare. But if you are not doing critical work, these versatile optics may be for you. For more information on zoom lenses, see Chapter 2.

CRITICAL FOCUS

No matter what accessories you choose for your close-up and macro work, keep in mind that having your subject sharp is extremely critical. Depth of field decreases as the lens-to-subject distance decreases, and a depth of field range of four inches to less than a half an inch is quite common. You will frequently find that there just isn't as much depth of field as you would like. You will have to make a decision concerning the point of sharpest focus.

If your lens' automatic diaphragm has been disconnected by the close-up accessory be sure to focus with the aperture wide open. Don't forget to stop down to the setting called for by your meter before you trip the shutter. Also, check the scene through the viewfinder after you have stopped down; with automatic diaphragms connected, use the depth-of-field-preview lever to accomplish this. Look for background distractions you may not have seen when the lens was wide open and depth of field was minimal.

A prime example of the shallow depth of field found in close-up photography. Photo by Maureen Brown Sechrengost.

You will quickly discover that conventional focusing methods do not work when using macro equipment. Changing the lens-to-film distance changes magnification more than it does focus, so you should set this magnification level first. Then move the whole camera-lens apparatus back and forth until the subject is focused. Sometimes it may be easier to move the subject, but either way, the results are the same.

Manufacturers seem to have accessories for every possible task, and macro focus problems are no exception. The more sophisticated bellows units have focusing tracks which allow you to move the whole unit very precisely; bellows units without this luxury can be fitted with such a device. Wait until the frequency and seriousness of your macro explorations warrant this expenditure, however. Many photographers simply wiggle the tripod or the subject back and forth.

HOLDING IT ALL TOGETHER

A great deal of your close-up photography can be done with hand-held cameras. If the light is bright and the resulting shutter speeds high, you should not have serious

problems with camera movement and vibration. If, however, you are making extreme close-ups and true macro shots (more than 1:1, remember), you will want to secure the camera and the subject to insure sharpness.

First steady the camera. When hand-holding, use the same good technique you would use with any lens and subject. Place your body in a comfortable position. If possible, lean against a wall, tree trunk, or other handy support. Bring your elbows into your sides to support your arms and squeeze the shutter slowly while holding your breath.

When conditions mandate a mechanical support use a good, steady tripod. Avoid those soda-straw tripods that may look convenient but provide nothing but a wobbly stand. A good tripod should weigh at least six to eight pounds. I have carried one that weighs twelve-and-a-half pounds through bogs and snow drifts because I know it will perform well when needed.

Because depth of field is so shallow, you will more than likely be using small apertures and long exposure times. With a long exposure, vibration becomes a problem, and you should use a cable release for tripping the shutter. If you do not have one handy, you can use the camera's self-timer.

Support the subject. Sharp photographs are very hard to make when your subject is dancing around in the breeze, and some support is usually necessary at this end of the photographer-subject relationship. When you can use high shutter speeds, one of the best subject-holders is at the far end of your arm. You will find it easier to hold something in your fingers if the camera is on a tripod, but you can get good results with the camera in one hand and the subject in the other.

Under extreme close-up and macro conditions, however, you will probably need some sort of holding device. Clothes pins, bits of clay, paper clips and children's construction toys can all be used to improvise needed structures.

One handy device you can make yourself consists of an alligator clip, (purchased at an electronics supply

This gadget costs about 50¢ to make. The only difference in this one and that mentioned in the text is that old baling wire was used instead of copper wire.

shop), attached to the end of a scrap of twelve or fourteen gauge copper wire you have obtained from an electrician or hardware store. The illustration shows how this device can be bent to any angle.

A Subject handling tip. If you are interested in photographing insects or cold-blooded animals, their movement will be slowed after a brief stay in your refrigerator. If you are working with snakes, be sure to warn the family.

EXPOSURE FOR CLOSE-UPS

As you move closer to your subject, the lens must be moved farther away from the film, and the light reaching the film diminishes. At moderate distances, this light loss is not a problem, but when making extreme close-ups and macrophotographs, some exposure compensation is necessary.

Fortunately, with modern SLR cameras through-the lens remains connected, simply follow the exposure cases where the automatic link between the camera and the lens remains connected, simply follow the exposure setting methods you would use under more ordinary picture-taking circumstances. The camera's meter will read the light available and translate that into the correct exposure information.

When the automatic feature has been disconnected, as with a reversed lens, for example, you will have to use

the stop-down or manual method. Check your camera's instruction book for the method used with your camera.

If you do not have a TTL meter here is how to figure the exposure correction:

1. Set up your shot and select the aperture you want to use.
2. Measure the distance from the center of the lens to the film plane at the back of the camera.
3. Divide this distance by the lens focal length and square your answer. This number is the *exposure factor*.

Use this exposure factor to determine the necessary exposure correction. If exposure times longer than one second are needed, you may have to compensate also for reciprocity failure. See Chapter 4 for an explanation of exposure factors and reciprocity failure.

LIGHTING FOR CLOSE-UPS

When lighting your close-up subjects, the effects of light are the same as for larger subjects. Shape and texture are brought out by the angle of the light. The hard or soft qualities of the illumination control contrast and influence the viewer's emotional response to the subject.

With close-ups, however, the lighting is sometimes harder to control. The surfaces are smaller and higher light levels are often needed to permit smaller apertures. As light sources you can use photo floods in reflectors, tungsten-halogen lights, electronic flash, or the sun itself. Electronic flash is a good choice if stopping movement and vibration are problems.

In many close-ups, texture is a prime point of interest. Keep in mind the use of side light for texture emphasis that was discussed in Chapter 3.

Shadowless Lighting

Some subjects, such as small metallic items, may need shadowless lighting. You can reduce the effects of shadows and reflections by working in open shade, or using

This plastic tent was lighted with the floods of the copy stand as shown in the next photograph. Any other light may be used on both sides of the tent for even illumination inside.

commercial reflectors, or pieces of white cardboard to bounce soft light onto your subject. The softest, most non-directional light is created by the use of a light tent. Made from an old bedsheet, this small tent is placed over your subject. A hole is cut in the tent for the camera's lens and the lights are directed through the sides of the tent. A tent for small objects can be easily made from a translucent plastic one-gallon bottle as shown in the illustration.

Spotlights can be useful for indoor set-ups of small items. By limiting the circle of light to the subject, the rest of the picture will be quite dark and your viewers' eyes will immediately focus on the item you are presenting.

Outdoors, time of day can be an important factor to consider in photographing those blossoms, bees, and butterflies you'll surely want to include in your macro work. Early morning or late afternoon hours will give you more dramatic lighting angles, and the colors of the sunlight will be warmer and the shadows cooler.

HOW TO COPY PHOTOS AND DOCUMENTS

If you are like many SLR owners, you will soon want to copy an old photograph of your ancestors, or important documents. Such tasks are easily accomplished with SLR cameras.

139

I use a large Saturn copy stand, which has arms on the sides
to hold the reflector bulbs, as shown in this illustration. This
stand may be a little large for the casual SLR user, but it will
handle any size copy camera I am likely to use, and is abso-
lutely steady.

Equipment

Any of the close-up and macro accessories previously dis-
cussed will work for copying, although edge sharpness
and straight lines are best preserved with a macro lens.

To prevent camera and subject movement, you can
use a tripod and pin the subject matter to a wall. Two
lamps of equal strength at 45 degree angles to the subject
produce the most uniform light. Open shade can be used in
an emergency. Direct sunlight will work if the subject is
smoothly textured. The main requirement of lighting is to
provide even illumination across the subject without re-
flections or emphasis of texture.

Copy stand. A copy stand, such as the one shown in
the accompanying illustration, provides a rigid camera
support for use when photographing flat or small three-di-
mensional objects. A moveable arm rides on the upright
tube and may be adjusted up or down. Many copy stands
also have arms at the sides which hold photo flood bulbs
for convenient, easy, even illumination. If you have need

140

of them, copy stands can make copy work and other close-up and macro pictures a breeze.

 Films For Copying. Any film can be used for copying. In color, your choice would depend upon whether you need transparencies or prints and whether your light source is daylight or tungsten. In black-and-white the fast, and therefore coarse-grained films, are less satisfactory than the slow and medium speed films. A good compromise is a ASA 125 film. Contrast is increased when copying. In black-and-white you may have to experiment with exposure and development. By increasing the exposure and reducing the development time you can lower the contrast of the negative. A decreased exposure and increased development increases contrast. Try a one-stop exposure change and a twenty percent change in development time for starters.

SLIDE DUPLICATING

One of the most interesting aspects of close-up and macro imagery is the making of duplicate slides. If you only need an exact duplicate once in a while send the job to a lab. But if you want to explore the many variations possible with cropping, changing color balance, making negatives from slides, and producing special effects, try slide duplicating.

Duplicating Equipment

Slide duplicating attachments are made by a number of manufacturers, and these devices often include a lens, a stage for holding the slide, and a means for varying the magnification and determining the exposure. Special duplicators which include light sources are also available. If you intend to do other macro work, the greatest versatility comes from a bellows unit with slide duplicating attachment. This attachment is usually just a device to hold the slide at the end of your bellows-lens combination.

 You will also need a consistent light source. I have had good results by aiming the beam from a slide projector

141

at my duping apparatus. Photo floods will work, but their color balance and intensity change as they age, and it is hard to get consistent results.

You can use any film for duplicating, but contrast build-up is a problem with many emulsions. Kodak Ektachrome Slide Duplicating Film 5071, designed for this purpose, keeps the contrast from becoming objectionable. There will be a color shift in the duplicate, and this is usually corrected by placing colored filters between the light source and the slide. You will have to test for the correct filtration and exposure. Instructions with the duplicating film give starting points.

Before you begin your duplicating project, check to make sure the slides to be copied are absolutely free of dust, lint, fingerprints and smudges. Lint and dust should be removed with a clean, dry, soft camel's hair or sable brush. Fingerprints and smudges may be taken off with a film cleaner and a wad of cotton (be sure it's real cotton, since synthetic material scratches). The oil from your skin can permanently damage transparencies, so avoid touching the film. Handle slides by the mounts, or by the edges of the film if unmounted. Spotless dupes can only come from spotless originals.

Slide duplicating is such an extensive and creative field that it can only be introduced to you here. For more information, see *The Manual of Slide Duplicating*, by Pat and Mike Q.

GET ACQUAINTED WITH THE SMALL, SMALL WORLD

We are surrounded by a fascinating world that most of us never discover until we really get serious about macro photography. The next time you have an opportunity to take your SLR out, do yourself a favor. Find a quiet place in your favorite garden, wooded area, park, or your backyard. Sit down. Look around. Then, with your macro attachments on your SLR, examine familiar things more closely. If there are flowers nearby sooner or later a bee or butterfly will arrive to taste the nectar. If you're leaning

Suggestions for practice subjects for your close-up and macro work include the whimsical half a cabbage. Try a tomato, an apple, a slice of orange. Use one light source and try moving it around. I guarantee you'll have some fun, and come up with some exciting pictures as well. Photo by Maureen Brown Sechrengost.

against the trunk of a shade tree scrutinize the detail of the bark. The tiny veins of a leaf assume more importance when viewed through a macro lens. A spider may be spinning a web, and if you're out early enough to catch the morning dew, the diamond-like sparkle will add a special glitter to your picture. Tall blades of grass, or grain silhouetted against a blue sky are beautiful in their simplicity. Weathered wood, or chunks of driftwood along a sandy beach offer texture and patterns not found elsewhere.

Open the door to the small, small world of close-up and macrophotography. You'll find it enchanting.

143

8

Show Off

GETTING THE MOST FROM YOUR BEST

When you have made photographs that you are proud of, you will certainly want to show them to others. Your sharing can be in the form of wall displays in your home or office, by means of slide shows, photo contests, exhibits, camera clubs, or many other ways. These ideas, as well as aids for enhancing those special scenes and subjects captured by you and your SLR, will be discussed in this chapter.

OFF THE WALL

Slide Shows

If you like to shoot transparencies, the most effective display of your work is the slide show. Good shows are made from *well* edited slides. Many of you have probably endured a friend's vacation slide show, during which some of the slides were upside down, some so underexposed that you couldn't see the subject, some could not be identified by the photographer, and some were the tail end of a roll taken last Christmas. You had to work hard to stay awake. Do not repeat these mistakes with your own shows.

Here are some rules for effective slide presentations:

Edit your work. Show only the *best*.
Put the slides in story telling sequences.

Be sensitive to the pace and timing. Keep the show moving along.

Have an intermission during long shows.

Have equipment and slides ready before guests arrive.

Have a spare projector lamp handy.

Music, either taped or on records, can add to a mood, and gives the photographer-projectionist a chance to rest his voice.

Leave your audience wanting more rather than having had too much.

If your slide shows are of community interest, or cover a specialty subject, you can find eager audiences among civic groups, clubs, and schools. For instance, your slides of world famous gardens would be of great interest to local garden clubs or shots of ancient coins would appeal to a numismatic club.

Be sure to test your show first on friends who will give you honest criticism. Polish the show until it's as good

If you're intrigued with something different, you may want to try posterization for some of your show-offs. This effect involves the projection of your negative onto a sheet of high-contrast Kodak film called Kodalith. This film is developed, dried, and then printed. The result is stark black-and-white prints with no gray tones, such as this one by 16-year-old Jim Skeen.

Want to try something like this for yourself? Do as Sloane Smith did. Find rim-lighted subjects (in this case, men seated on a park bench); use a slow shutter speed (try a one second exposure); and move the camera during the exposure. The wilder you get with your experiments, the wilder results you'll have!

as it can possibly be then proudly share your experiences with your community.

Exhibitions

Local libraries, banks, and other places where the public gathers are potential sites for a photographic display. Whether you plan a one-person show or a group effort with a few friends, be sure you hang only the very best work, and that the mats and frames are neat and clean.

To make arrangements, contact the person in charge of public relations and work with that individual as to size and number of prints to be displayed. Plan dates far enough in advance to be able to get publicity in local newspapers.

Clubs and Contests

Photography clubs are an excellent means for finding help with your photography. Meetings often include critique sessions, and creative ideas flow faster when you are around others who share the same interests. Clubs sometimes have darkroom facilities and studio space. Often prominent photographers visit to speak and present work, or conduct master classes. Field trips and contests are important parts of club activities.

A camera club is one of the best places for the beginning photographer to show his work. Suggestions for continued improvement come from other beginners as well as from the more advanced club members.

If you can not find a club near you contact: Membership Department, Photographic Society of America, 2005 Walnut St., Philadelphia, Pa. 19103.

Photography contests are run by many organizations, and sometimes large prizes and recognition can result from a winning entry. Contests among friends, clubs, or at county fairs are good ways of seeing other photographers' work, as well as showing your own. Local newspapers frequently sponsor annual contests. Before you enter large contests or those which are commercially sponsored, be sure you read the rules carefully. Some contests do not return entries, and may require that entries become the exclusive property of the sponsoring organization. Some unscrupulous firms use this as a means of obtaining a large file of photos without paying for them.

Photos as Gifts

A gift of photography can be a very personal one. An image that you have made and finished for display often evidences more thought and intimacy than a mass-produced item purchased at a store. When giving photographs, especially for wall display, consider carefully the tastes of the recipient. An embarrassing situation could arise if the image is in the wrong style. One photographer friend presents hand-made certificates, which the honored recipient may redeem for a print. The person then visits the darkroom and chooses an image from the photographer's file.

The miniature purse-sized album, such as Grandma's Brag Book, filled with recent pictures of grandchildren, is an instant success as a gift. Wallet-sized prints of loved ones are prized by family and friends. Small prints can be used as personal postcards or greeting cards, and there is even a black-and-white postcard paper available for those who enjoy darkroom work. Also for the darkroom buff are calendar masks for making person-

alized calendars to be used as gift items. For the non-photographer friend who shared a vacation with you an album of vacation pictures will be treasured.

The photographic gift can be much appreciated, if only you give a little thought to what item might be appropriate.

Other Show-Offs

Many plastic devices are available in which you can place prints for counter or table display. Craft shops may have some ideas for you along the line of découpage, which is a method of adhering a print to a piece of wood or other support, and covering the combination with coats of clear or antique crackled lacquer.

ON THE WALL

Giant murals, large posters, groups of large and small prints, and mixtures of pictures and memorabilia are used today as never before for important decorating statements in home and office decor.

You have walls that need to be decorated. Now that you've studied this book, practiced and experimented, shot and reshot, edited, considered and rejected, you are delighted to find that you have literally dozens upon dozens of really top-notch pictures that are worthy of wall display. Before those pictures reach the walls there are a number of points for you to consider.

Print Size

One of the discoveries that beginning photographers make is the power of the large print. If you are used to looking at nothing larger than scrap-book sized prints, an 8 x 10 print may look gigantic when you hold it in your hands. However, that same print may suddenly become very small if it is hung in the middle of a wall. Your display thinking

should include the possibility of much larger prints. Sizes such as 11 x 14, 16 x 20, 20 x 24 inches are common.

When deciding upon print size, remember that small prints frequently need close inspection, while large ones can be comfortably viewed from a distance. If your photograph is to be the main piece of wall decor behind a couch, for example, use a print of at least twenty inches across. Over a nine-foot couch, even a 16 x 20 print may be dwarfed, so you might consider an arrangement of two or three 16 x 20 prints for maximum impact.

If the viewing distance is likely to be close, such as in a hallway, smaller prints are easier to see.

Print Quality

Ansel Adams has compared the photographic negative to a musical score and the print to the performance. This is an excellent analogy. The best image is only as good as the print. Your display prints should be only the very best. If you make your own, display only those prints you can be proud of. Those you have to make excuses for should be thrown into the trash. When ordering prints from commercial laboratories, you will get more personal attention from smaller custom labs than the large ones whose profits depend upon volume.

How to Crop Prints

There are standard sizes for photographic prints only because there are standard sizes of printing paper. You are certainly free to crop your prints to any proportion called for by the image. I recall an exhibition I once did in Alaska where the subject was "Aboriginal Artifacts of Alaska." Many Indian totems were pictured but not shown in standard-size prints. Sizes such as 5 x 11, 8 x 20 and 10 x 24 were used. The formats fit the images.

To help you determine proper cropping, use two pieces of scrap cardboard or mat board cut into large L shapes. By moving these two L's around on your print, framing in different ways, you can mask off various areas to find the best cropping. Cropping choices depend on

149

Cropping "Ls" make it easy to visualize a print in a different com-position. Try using the Ls on some of your old prints and see if you can't come up with some ideas for cropping that will improve them. After some experience with the Ls you'll soon be able to better visualize in the viewfinder of your camera and will not need any additional aid.

taste and the compositional principles discussed previously.

Look for new compositions in your photo. You might even find more than one, and you can decide on one possibility, or have another print made and enjoy both options.

After you have decided on the cropping, you can either cut the print to the new dimensions or mask off unwanted areas with a mat. (You will see how mats are used shortly.) Or have another print made to the dimensions you have decided are best.

Slides. Although you can't display slides in the same manner as prints, you may have prints made from the slides for your wall, and you have the same cropping options. Special slide mounts are available with various size openings. You have only to look through the assortment to find one that is appropriate. Your local camera store should be able to get these mounts for you. You can also create your own special masks by removing the slide from the mount and carefully covering the unwanted areas with draftsman's

Barbara Baldassano was quick enough with her SLR to capture a moment of quiet communication between husband Tony and baby Brian. She increased visual impact of the moment by cropping all the nonessentials from the photograph while printing it. Because the negative was a little "soft" for the amount of enlargement necessary for the print, she added a texture screen to improve the final print.

chart-making tape. Test the tape you plan to use on a scrap slide to make sure it is opaque. Sophisticated ways of masking and cropping slides are described in detail in *The Manual of Slide Duplicating*, by Mike and Pat Q, and *Making Slide Duplicates, Titles and Filmstrips*, by Norman Rothschild.

PREPARING FOR DISPLAY

The effectiveness of your display is greatly influenced by how the prints are presented. You have made your choices, have obtained the best prints possible, have made

certain that dust spots have been eliminated, and are ready for the next step.

Print Mounting

Prints hung on the wall should be supported by some sort of backing, at least a medium-weight board to provide rigid support. The best mounting method is to use heat sealing adhesive tissue and a special mount press such as those made by Seal, Inc. These presses use heat and pressure to melt the adhesive tissue placed between the board and the print to make a permanent bond.

Other adhesives such as sprays and double-stick papers also work well. When mounting, you again have the choice of using a board the same size as the print—called flush mounting—or using an attractive white, black, or colored board, and carefully positioning the print so that the board extends beyond it.

When selecting mat board do not settle for the poster boards frequently found in variety stores. Visit a large photographic or art supply store and look at the many varieties of mat board available. Colored and textured board should be selected with the print at hand so you can be sure the two items will look good together.

Matting

Matting is the process of placing a piece of board over the print. The board has had a window cut out of it through which the print is seen. Matting is a useful display technique because mats can be changed when dirty or faded, or colors changed to suit your whim. Mats can also help to set off the print and give it importance. You can buy inexpensive tools for cutting windows out of mats, or you can have the work done by a frame shop. A combination mat-mount board is also available with window openings of standard print sizes.

Framing

When framing your prints, you have so many choices that it is sometimes hard to make a decision. You can order custom frames, buy ready-to-use frames at frame shops, or

even make your own. Inexpensive frames can often be given a custom look with the help of a little spray paint. The color chosen can be one picked from the room decor and can help to tie the design scheme together.

When choosing the style of your frames, you will probably find that photographs look better in simple ones. Ornate frames that might be appropriate for oil paintings often compete for attention with photographic prints. Some variety in style can certainly be used. Every frame in your home or office need not be identical.

Unless photos are subject to extremely dirty conditions, do not place them under glass. The reflections from a piece of glass will make the image hard to see. If you *must* use glass, use only clear window glass. Non-glare glass diffuses the image and mutes colors.

An alternative to frames are clip-like devices which grab the edges of the mounted print and provide a means for hanging it. These clips can be used with or without glass, and the prints can be easily removed if you like to change your display frequently.

Designing the Space

Rather than randomly hanging your prints on the wall take some time to coordinate the elements.

Tape large pieces of brown wrapping together so the total is the same shape and size of the wall space you intend to use for your display. Other pieces of newspaper can be cut to the sizes of your prints. Make up a proposed arrangement on the floor, so you can see the relationships between the sizes. If you have finished prints, by all means, use them, as the subject matter in each one may influence your decisions. Try to find a feeling of balance. Consider the spatial relationships of everything on and in front of the wall. Refer again to compositional principles since they apply to this project, too. Move prints around on the brown paper until you are sure which arrangement works best. Then hang them. By trial and error efforts on the floor, you can save yourself unnecessary nail holes in the wall.

Remember to give some thought to the wall itself. If it is covered with a busy wallpaper or is in need of paint, a

An even top line unifies this stairwell display of photos on two walls. Prints are large enough (the smallest is 11 × 14) to be seen conveniently from the stair railing.

change here might improve your display's impact.

Consider the lighting as well. Track lighting is an effective means for accenting your work.

For more ideas, Kodak book number O-22, *Photo Decor—A Guide to the Enjoyment of Photographic Art*, is one of the best on the market.

ONE FINAL FRAME

You have now finished my book. I hope that it has been of help to you in your pursuit of finer photographic images. It has been my pleasure to share with you some of my experiences. And who knows, maybe we'll meet one of these days, SLRs in hand. I hope so. But if not, happy shooting for the rest of your days, wherever you may be.

Weathered bricks and a shadowed door . . . and a sign that says it all. No matter how many books you read, classes you attend, or exposures you make, in the end, "It's Up To You."

Appendix

Metric Conversion Information

When You Know	Multiply by	To Find
inches (in.)	25.4	millimetres (mm)
feet (ft.)	0.3048	metres (m)
miles (mi.)	1.609	kilometres (km)
ounces (oz.)	28.349	grams (g)
pounds (lbs.)	0.453	kilograms (kg)
pounds per square inch (psi.)	0.0703	kilograms per square centimetre (kg/sqcm)
cubic feet (cu. ft.)	0.0283	cubic meters
Fahrenheit temperature (F)	0.5556 after subtracting 32	Celsius temperature (C)
fluid ounce (oz.)	29.57	millilitres (ml)
quart (qt.) (U.S.)	.9472	litre (l)

ASA AND DIN FILM SPEEDS

ASA	DIN	ASA	DIN	ASA	DIN	ASA	DIN
6	9	25	15	100	21	400	27
8	10	32	16	125	22	500	28
10	11	40	17	160	23	640	29
12	12	50	18	200	24	800	30
16	13	64	19	250	25	1000	31
20	14	80	20	320	26	1250	32

Index